BEAR
The Ultimate Artist's Reference

A grizzly bear pauses while frolicking in a southcentral Alaska pond to eye the photographer.

BEAR
The Ultimate Artist's Reference
By Doug Lindstrand

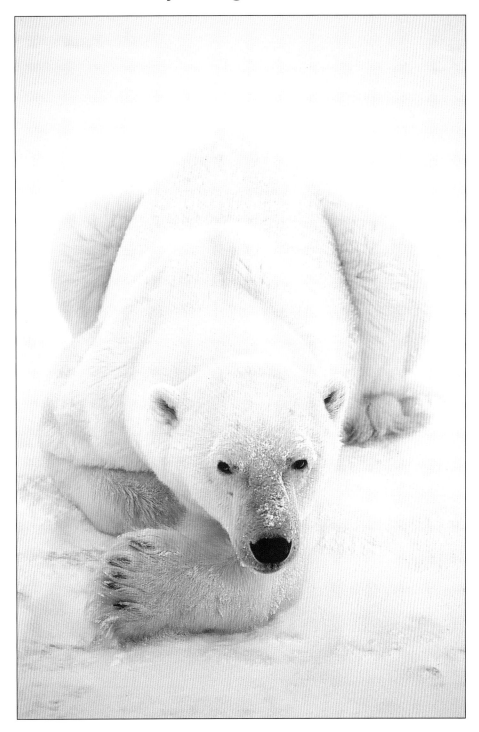

Fox
Chapel Publishing Co. Inc.

1970 Broad Street • East Petersburg, PA 17520 • www.foxchapelpublishing.com

Dedicated to all wildlife artists.

Publisher	Alan Giagnocavo
Book Editor	Ayleen Stellhorn
Cover Design	Jon Deck
Desktop Specialist	Linda Eberly, Eberly Design, Inc.
Photographers	All art and photographs by the author except as noted. Tom Soucek (tsoucek@alaskalife.net): Photographs on pages 1, 37 (top), 39, 77, 78, 82, 93 (bottom), 94, 97, 98, 107, 111. Ole Westby (www.westby.ca): Photographs on page 103.

ISBN 1–56523–214–3
Library of Congress Preassigned Card Number: 2003107293

To order your copy of this book,
please send check or money order
for the cover price plus $3.50 shipping to:
Fox Chapel Publishing Company, Inc.
Book Orders
1970 Broad St.
East Petersburg, PA 17520

Or visit us on the web at
www.foxchapelpublishing.com

Manufactured in China
10 9 8 7 6 5 4 3 2 1

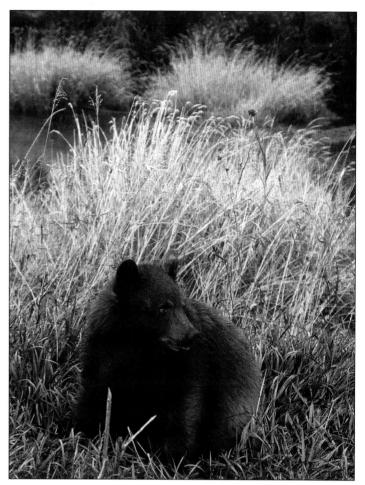

Black bear cub (Idaho)

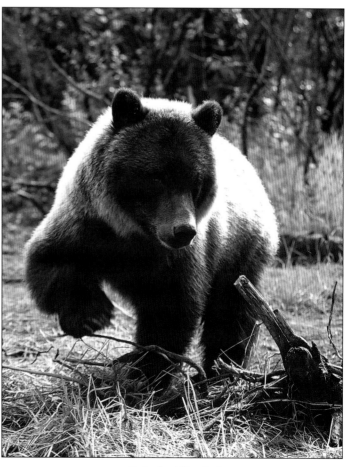

Grizzly (Alaska)

Table of Contents

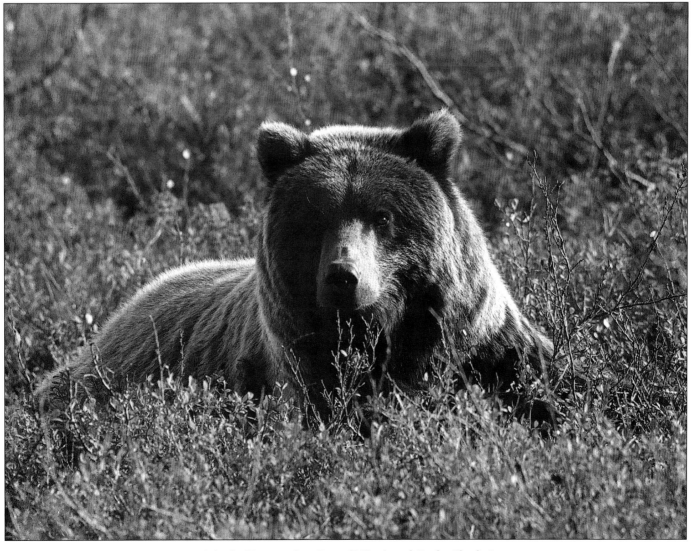

Grizzly (September/Denali National Park, Alaska)

Artist's Comments

The photographs in *Bears: The Ultimate Artist's Reference* were taken over many years as I crisscrossed North America. The sketches were done in the field, back at my various base camps, and also at my Alaska studio.

Bears are North America's most feared and dangerous predators, and the thrill of spending countless weeks in the field with these noble and magnificent beasts has been an indescribable honor. I have been in close quarters with hundreds of bears, and the only time I have been in serious danger was the time I unknowingly came upon one feeding on a caribou kill. I only escaped harm by being able to claw and pull myself up a bluff before the charging bear reached me. I have always tried to travel with caution in Bear Country and to show respect for the various animals I encounter in their wild home. I normally advise novice bear photographers to never think you know what a bear is going to do, as the bear itself seldom knows. Doing something stupid could easily get you killed.

My hope is that this guidebook will help artists who carve, draw, paint or otherwise portray bears in their artwork. I have included young and mature bears and have used sketches and photographs that illustrate these animals from various angles and in various seasons and colors.

Happy Trails,

Note: The artist tried to illustrate the bears as accurately as possible. Also (especially on the polar bear) he chose to make the drawings extra dark in order to better show detail, muscles and hair direction.

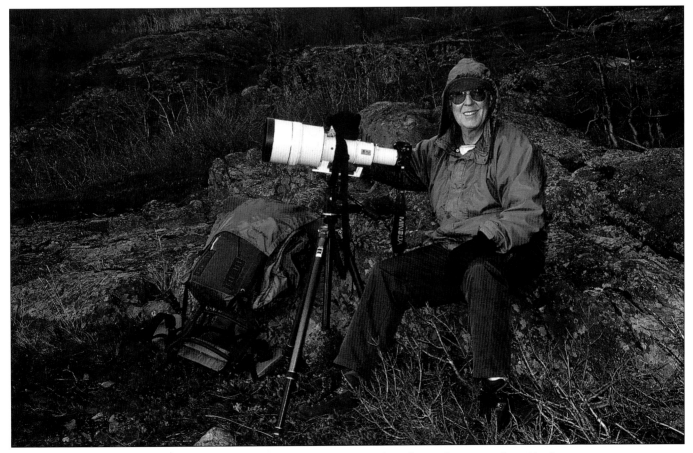

The author, Doug Lindstrand, at work in the Chugach Mountains, Alaska

Introduction

This book is made up of pencil drawings and photographs; however, I also wanted to show how I sometimes put a drawing on watercolor board, spray it with a fixative, and use watercolor or pastel to turn it into a painting. If you use watercolor on board or paper not designed for these mediums, the board or paper will buckle. Therefore, in the preliminary steps of composing your artwork, you must determine what form the finished project will take. The pictures of "Don't Mess With Mom" (grizzly bears in Denali National Park, page 3) and "Peaceful Arctic" (polar bears on Alaska's icepack, page 4) are examples of this technique.

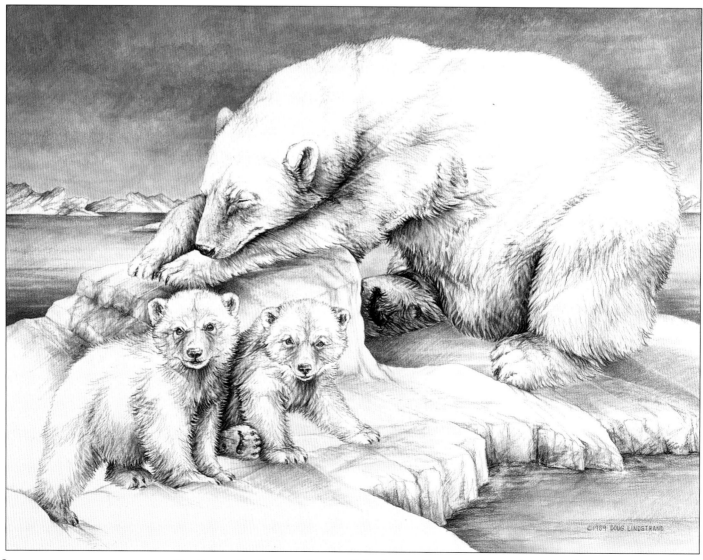

Resting polar bear and cubs. Painting by Doug Lindstrand.

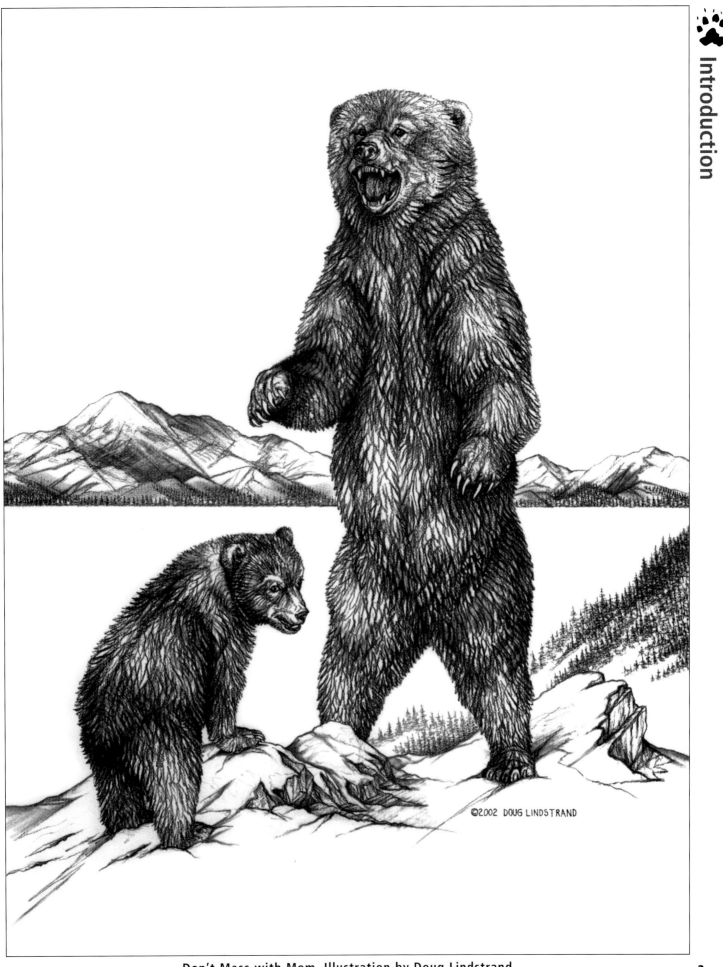

Don't Mess with Mom. Illustration by Doug Lindstrand.

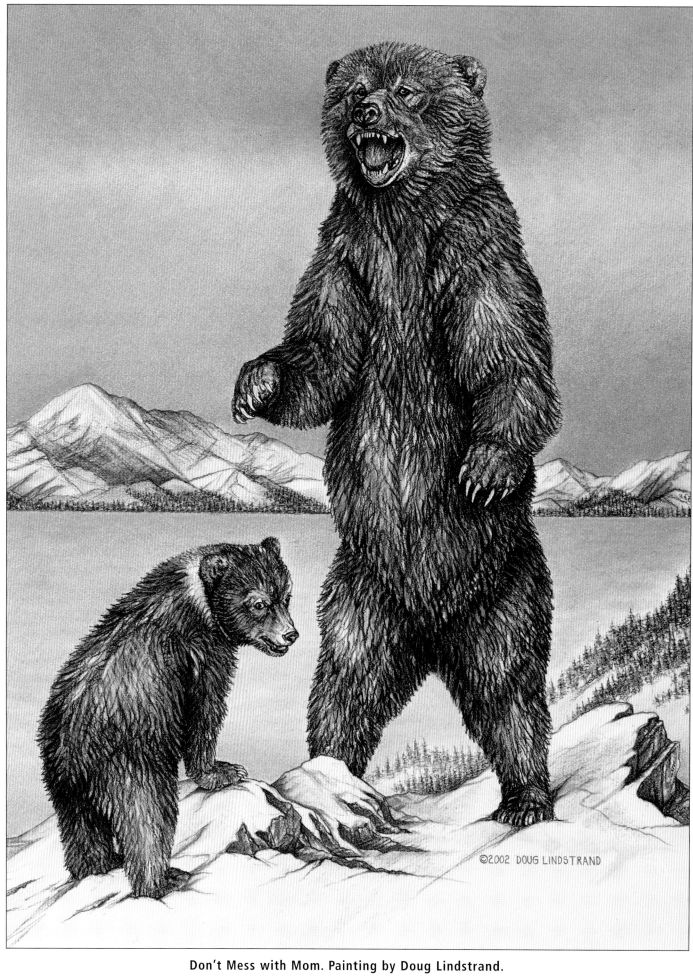

Don't Mess with Mom. Painting by Doug Lindstrand.

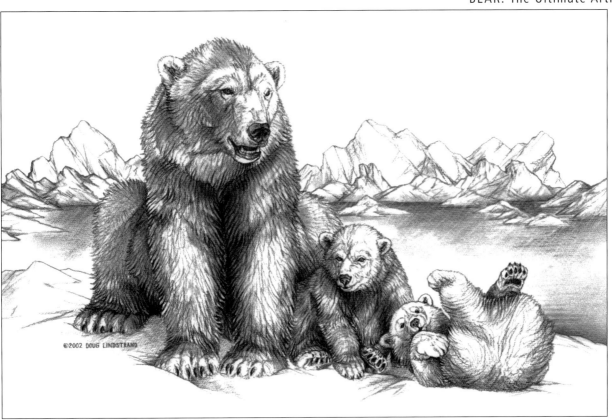

Peaceful Arctic. Illustration by Doug Lindstrand.

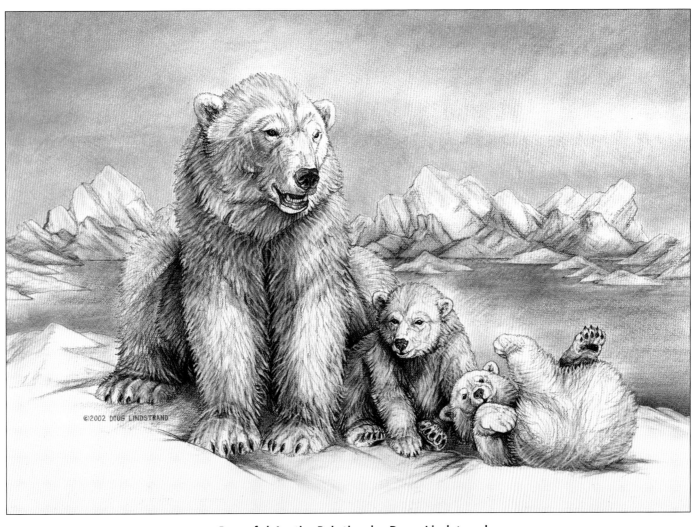

Peaceful Arctic. Painting by Doug Lindstrand.

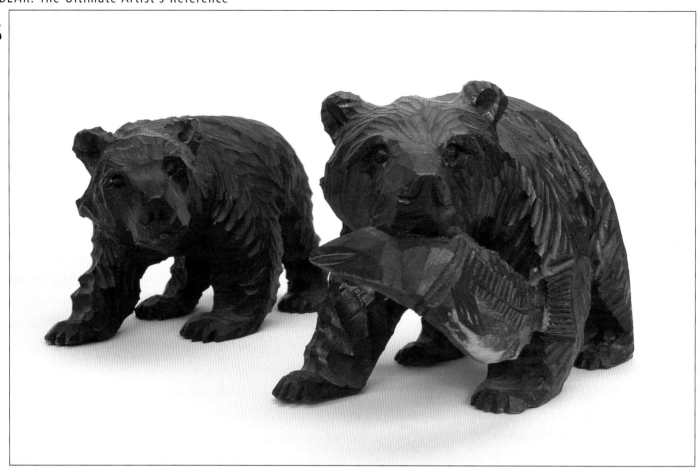

Two black bears. Carved/painted wood. Carver unknown.

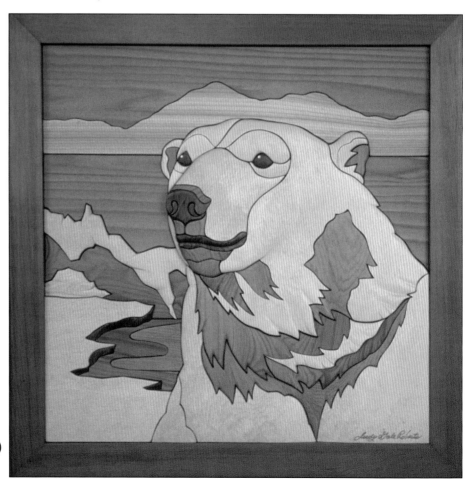

Polar bear. Intarsia picture (wood)
by Judy Gale Roberts.

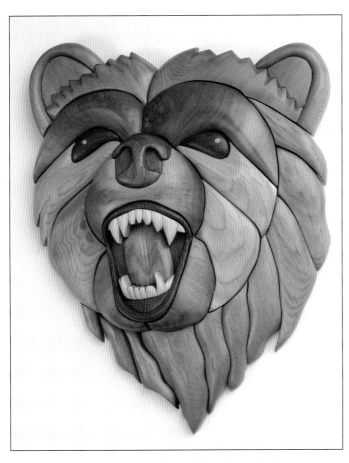

Bear. Intarsia picture (wood) by Dennis Simmons, based on a pattern by Susan Irish.

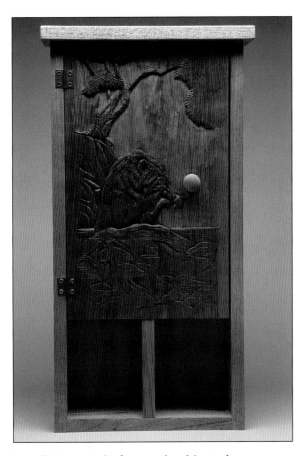

Bear fishing. Relief carved cabinet door by Susan Irish.

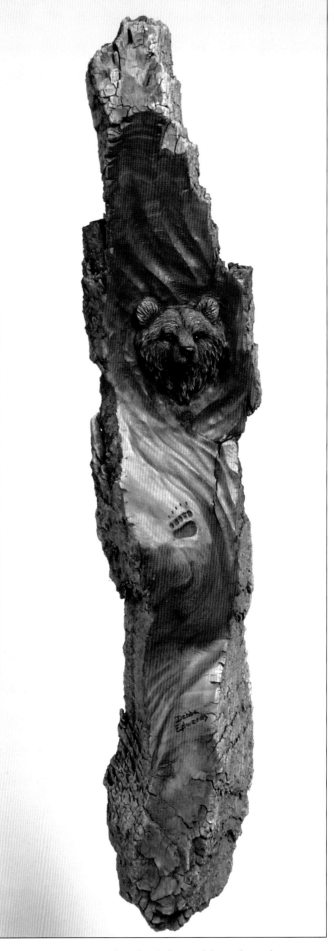

Bear. Carved in bark by Debbe Edwards.

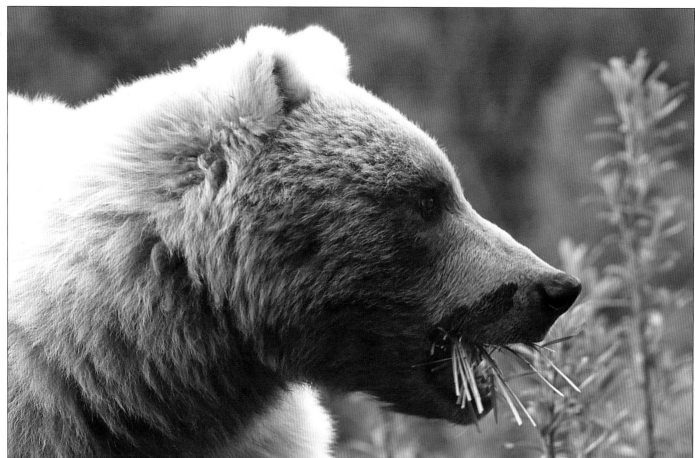

Grizzly, female

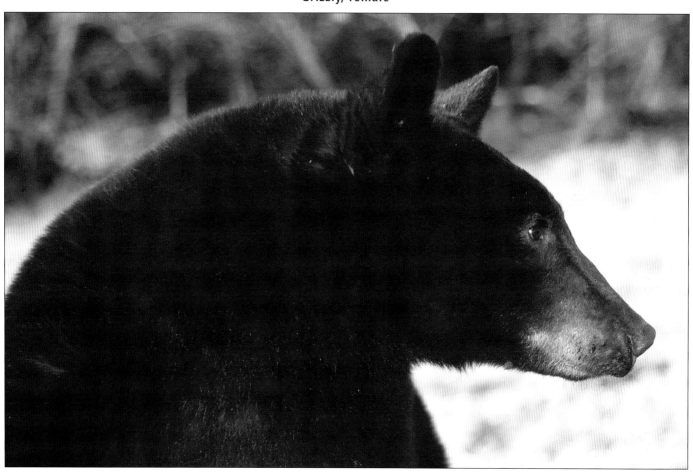

Black bear, female

Bears of North America

The bears of North America consist of the black bear, grizzly bear (also called the brown bear) and polar bear. These three species are the continent's largest terrestrial carnivores and can be very dangerous under various circumstances. When sketching, photographing and hiking in bear country, one must be very careful not to surprise a bear, especially if it is feeding, injured, mating or with cubs.

Normally the three species live in different environments and only seldom come in contact with each other. Except for the polar bear, bears are predominantly vegetation eaters; however, all bears will hunt and eat meat if the opportunity presents itself.

North America's bears all belong to the family Ursidae and are distinguished by their large heads, rounded ears, small eyes, heavy bodies and powerful limbs. Their fierce appearance and reputation make them a favorite subject among the world's wildlife artists.

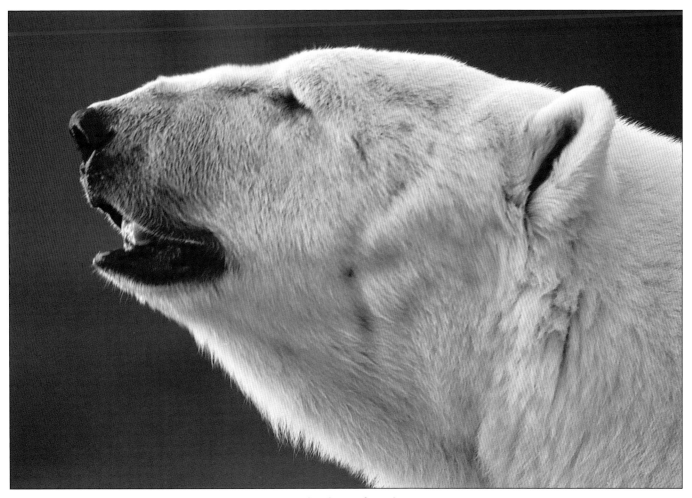

Polar bear, female

Black Bears

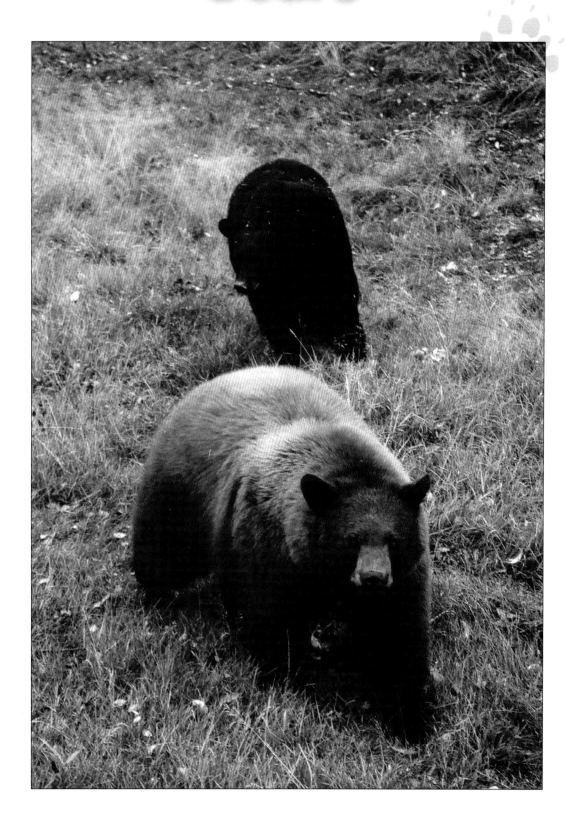

The black bear (Ursus americanus) is the most numerous of North America's bears. Recent surveys estimate its population at over 400,000, and it still ranges widely from Canada south into Mexico. The black bear's adaptability allows it to thrive in a variety of habitats and near humans. It is the smallest of North America's bears, but an occasional large male can weigh over 600 pounds. On average, however, males weigh 150 to 300 pounds.

Black bears vary in color from white to black. Most northern black bears are black, but those from the warmer regions of North America are commonly a brownish color. Southeastern Alaska has a small population of glacier bears, a bluish-gray color phase of the black bear, and the Kermode bear of British Columbia's Princess Royal Island sports a beautiful yellow-white coat.

Black bear cubs are born in January and February, and an average litter is two. When the family leaves its winter den, the cub will weigh six to eight pounds and is strong enough to climb trees in the event of danger. Studies have shown that 30 to 40 percent of cubs die from predation, starvation or accidents before their first year of life ends.

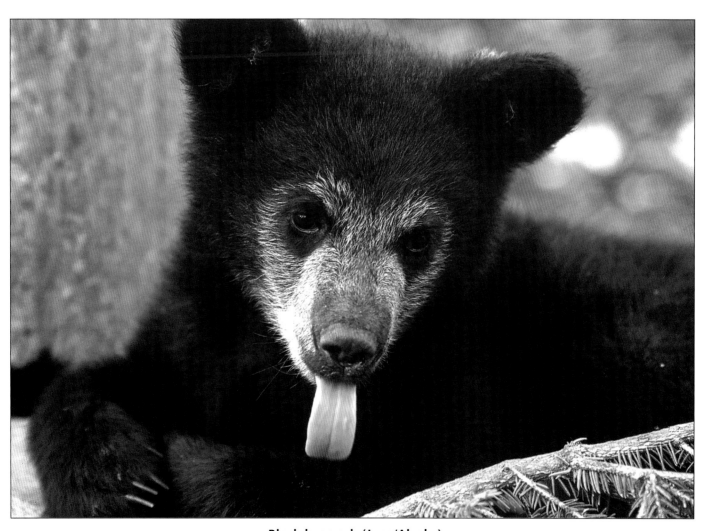

Black bear cub (June/Alaska)

Black Bears

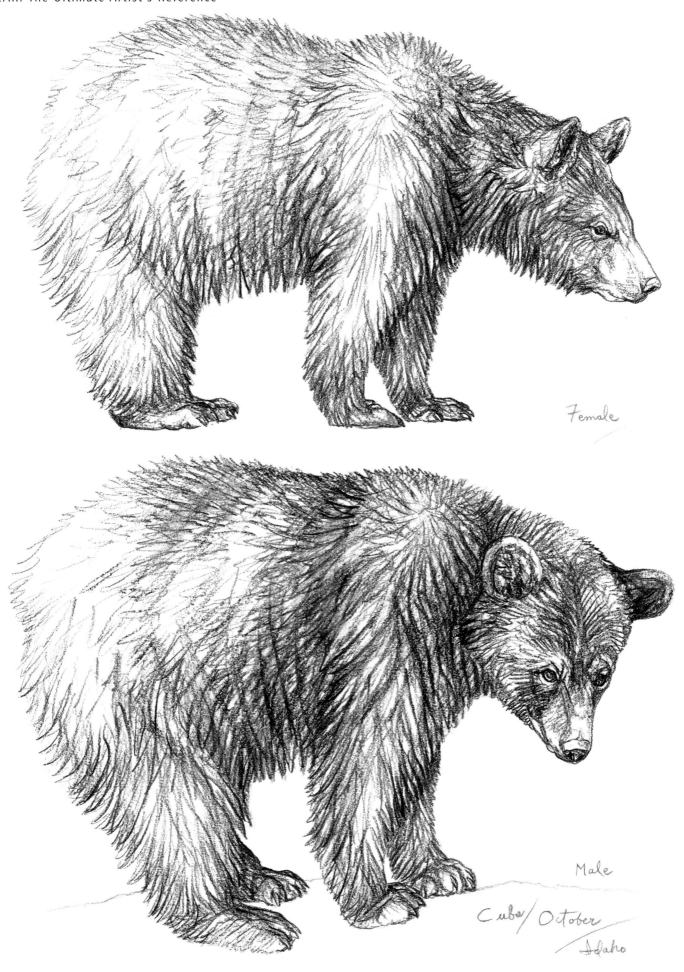

Female

Male

Cubs/October

Idaho

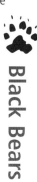

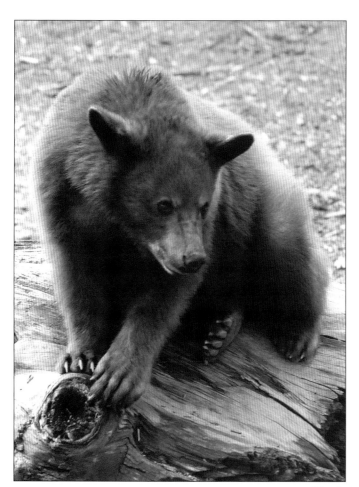

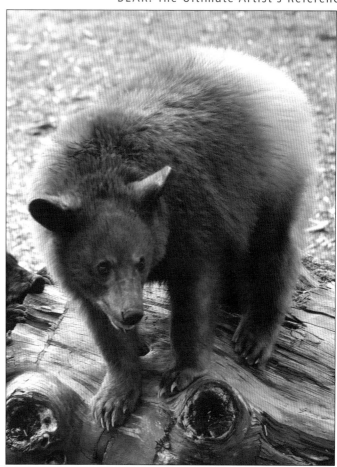

Black bear cub

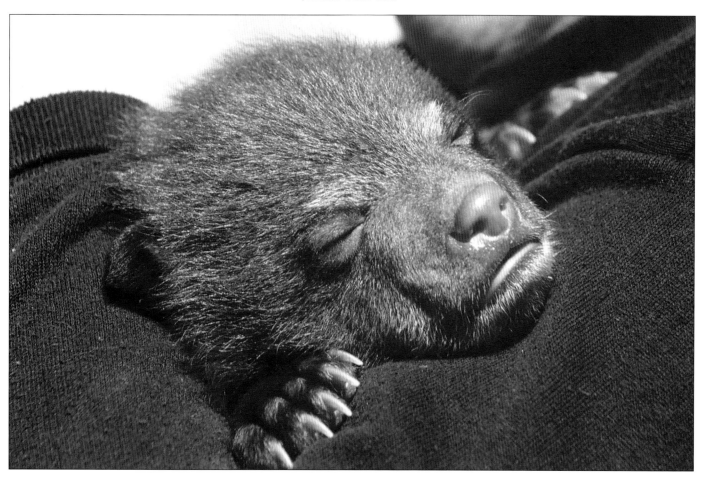

Black bear cub (March)

Black Bears

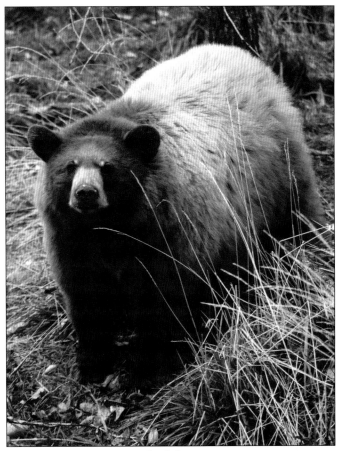

Black bear

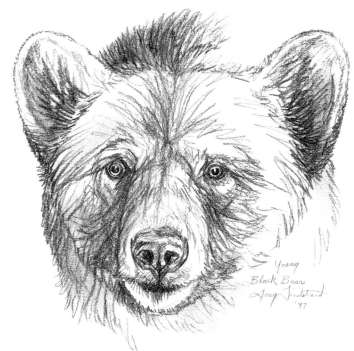

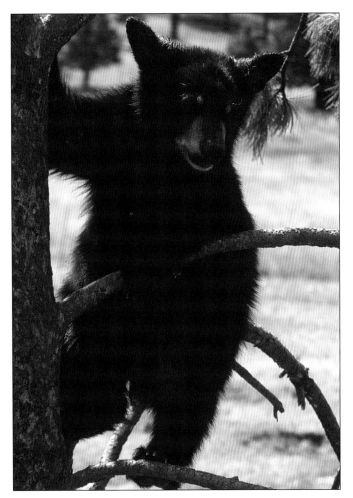

Black bear cub in tree

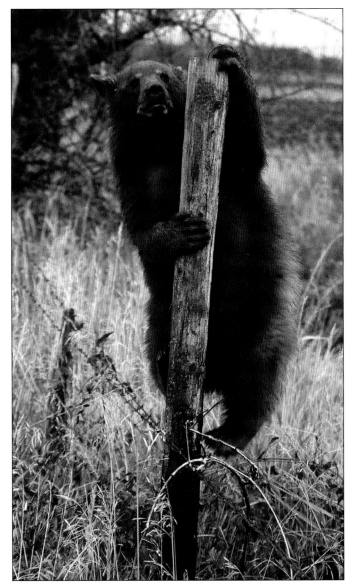

Black bear cub climbing over fence (Idaho)

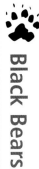

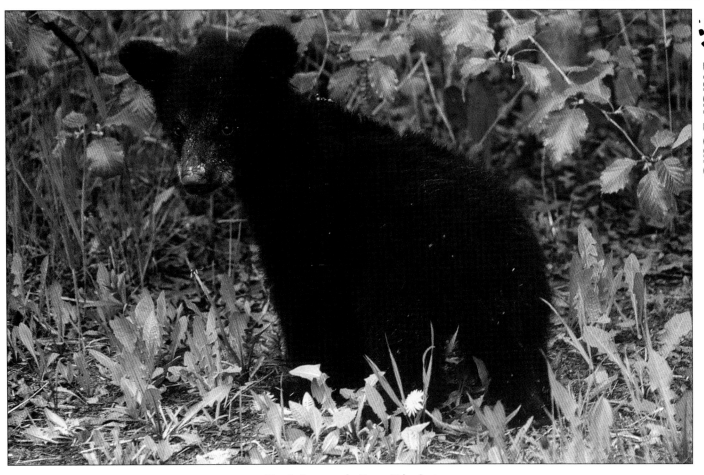

Black bear cub (June/Alaska)

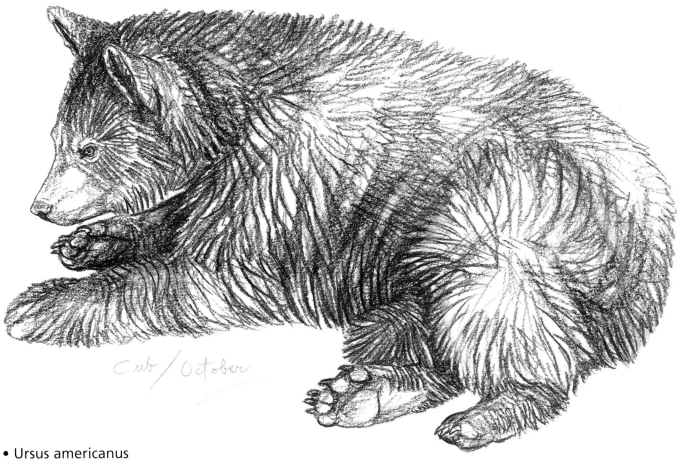

Cub/October

• Ursus americanus
 There may be over 400,000 black bears in North America.

15

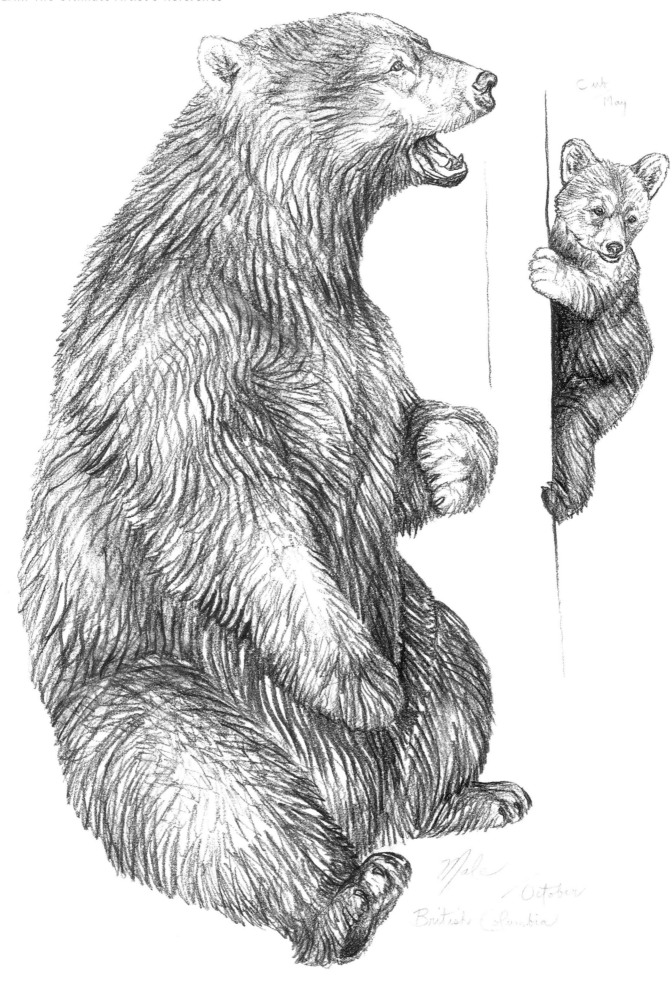

Cub
May

Male
October
British Columbia

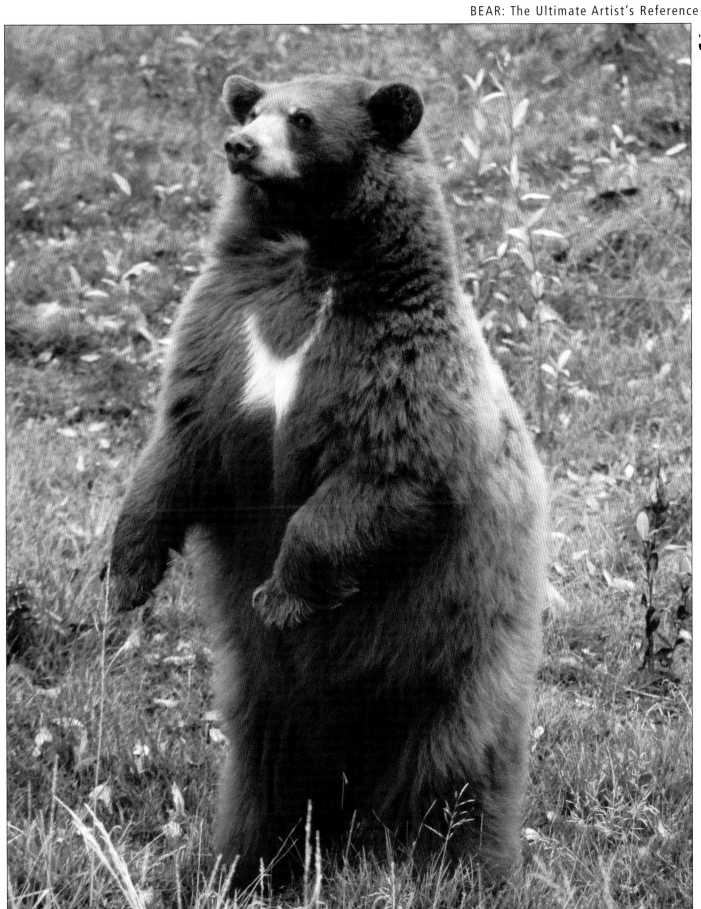

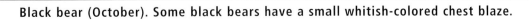
Black bear (October). Some black bears have a small whitish-colored chest blaze.

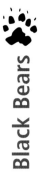

• Newborn black bear cubs weigh about 12 ounces and are about 8-9 inches long.

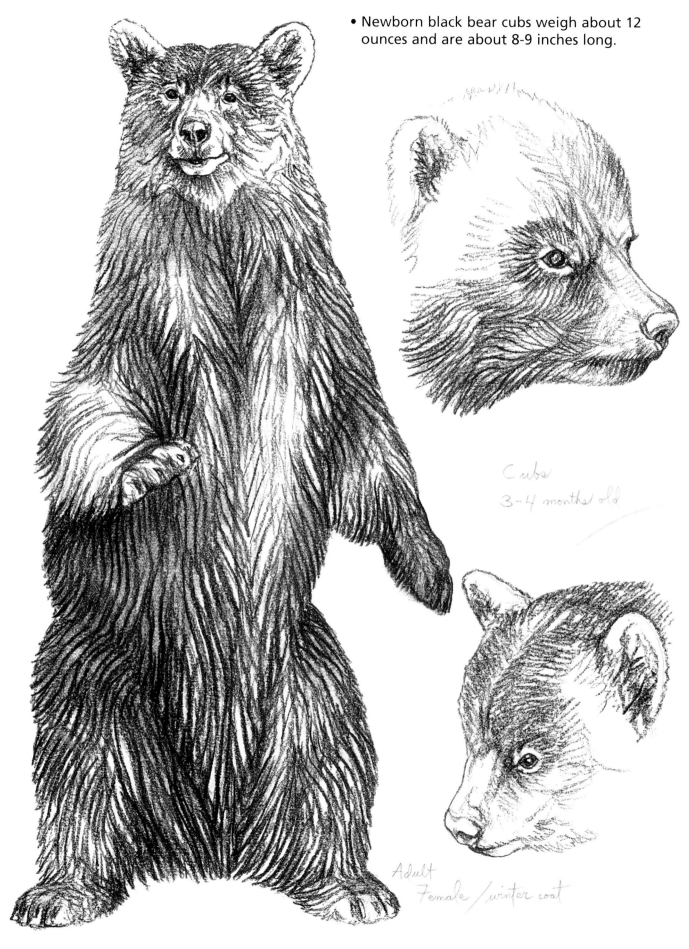

Cubs
3-4 months old

Adult
Female /winter coat

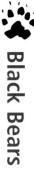

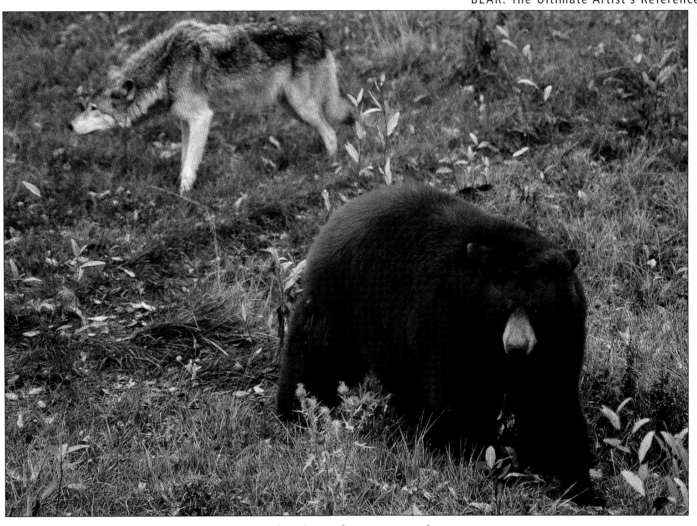

Bears and wolves often compete for prey.

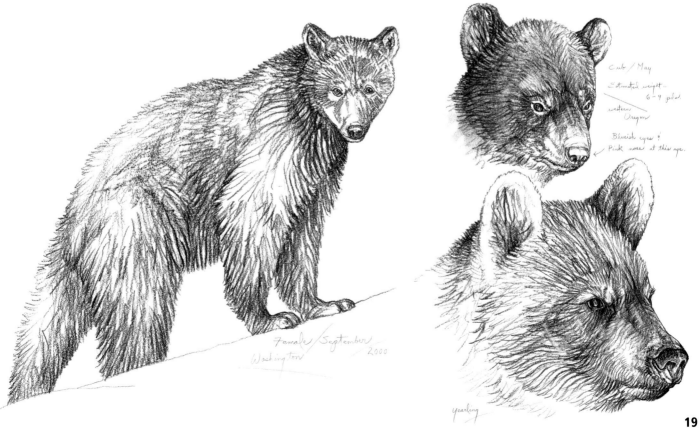

Cub / May

Estimated weight
6 - 9 pound

western
Oregon

Blueish eyes &
Pink nose at this age.

Female / September
2000
Washington

yearling

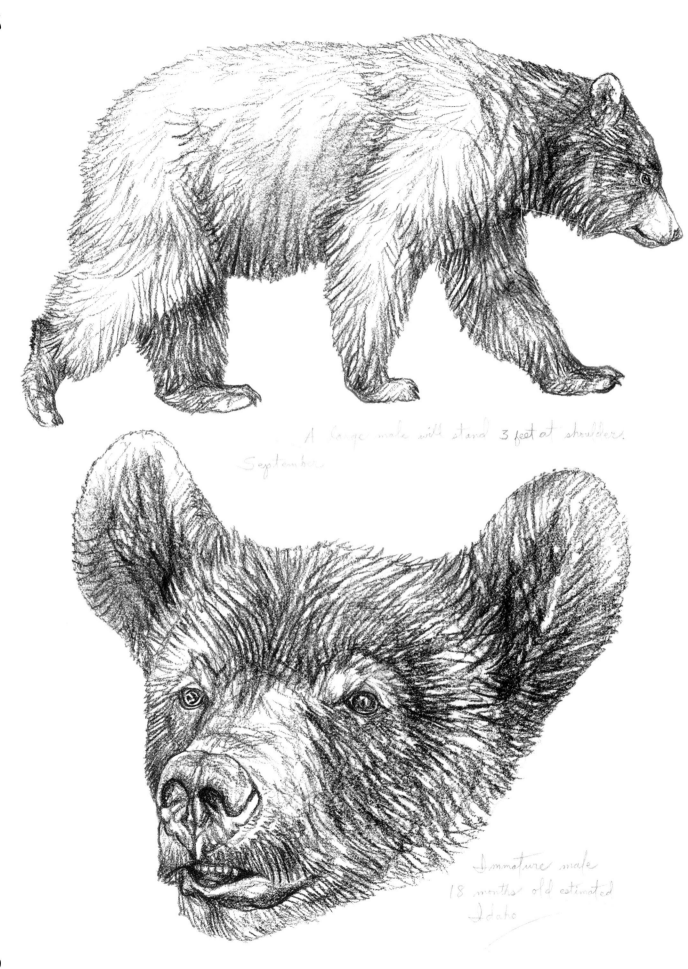

A large male will stand 3 feet at shoulder.
September

Immature male
18 months old estimated
Idaho

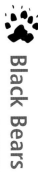

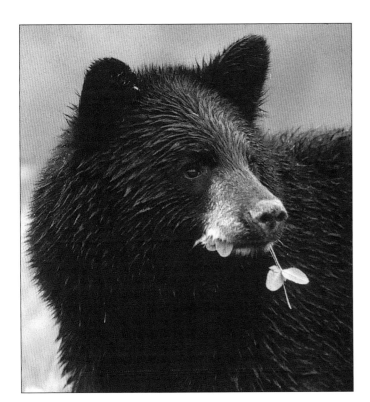

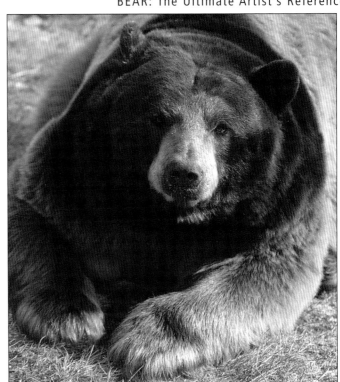

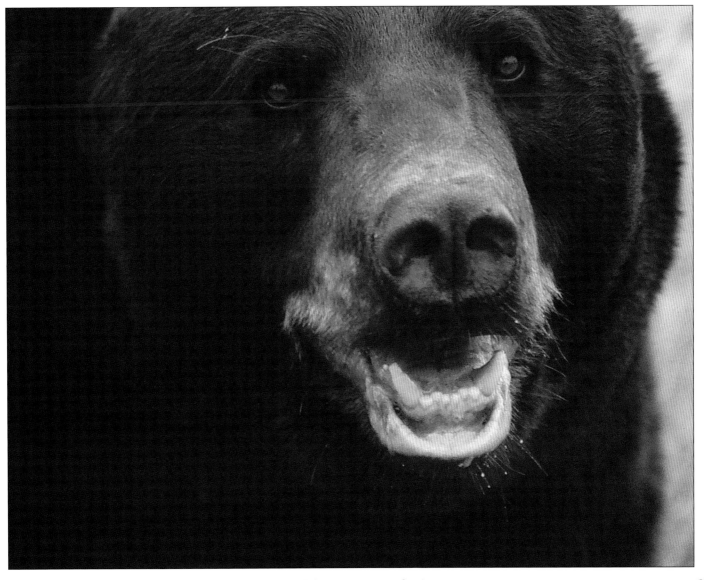

Black bears (September)

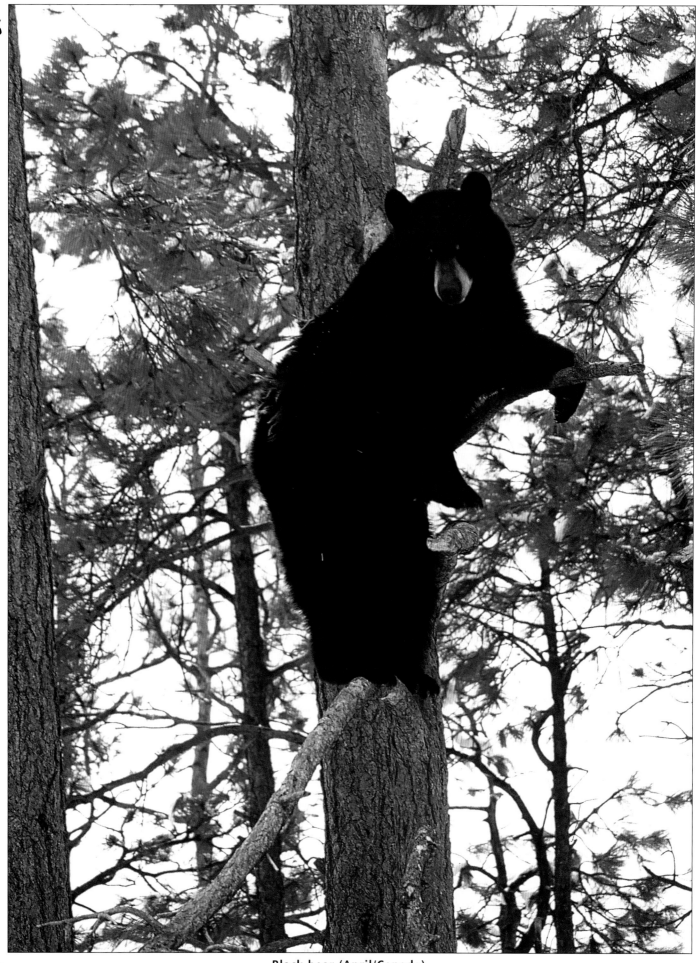

Black bear (April/Canada)

• A black bear's head is narrower and smaller than that of a grizzly bear.

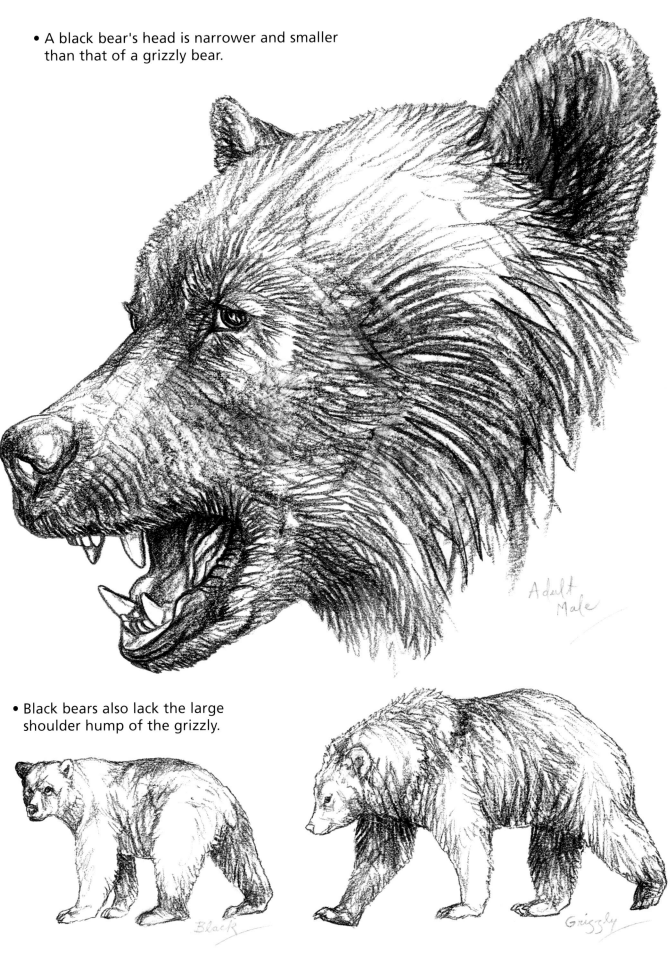

Adult Male

• Black bears also lack the large shoulder hump of the grizzly.

Black

Grizzly

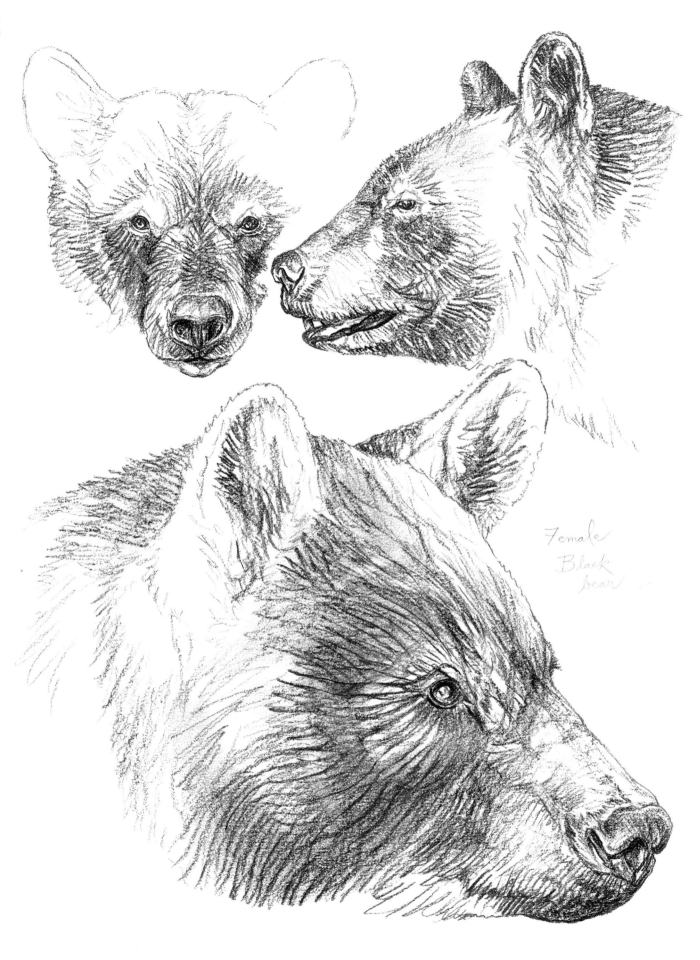

Female
Black
bear

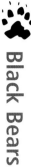

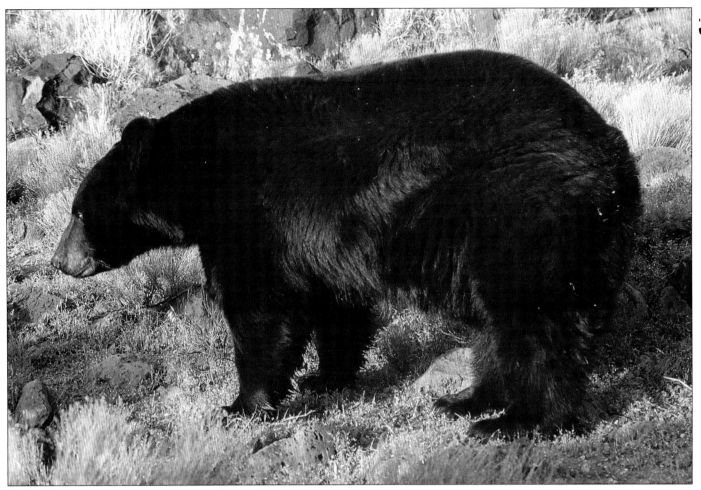

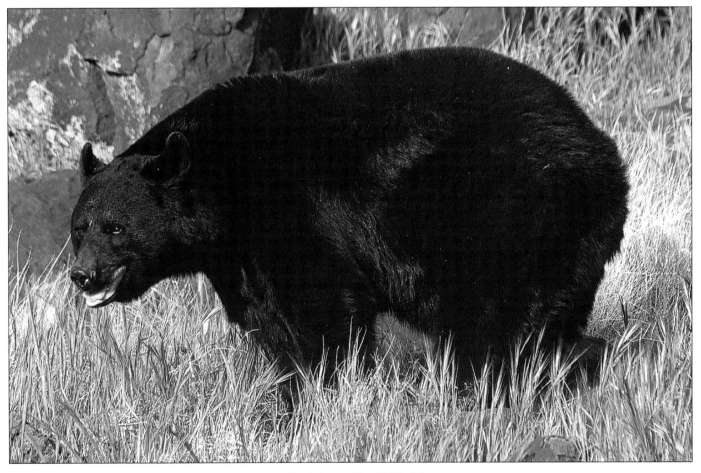

Black bear (April/Utah)

• Female black bears usually breed for the first time when they are three and one-half years old.

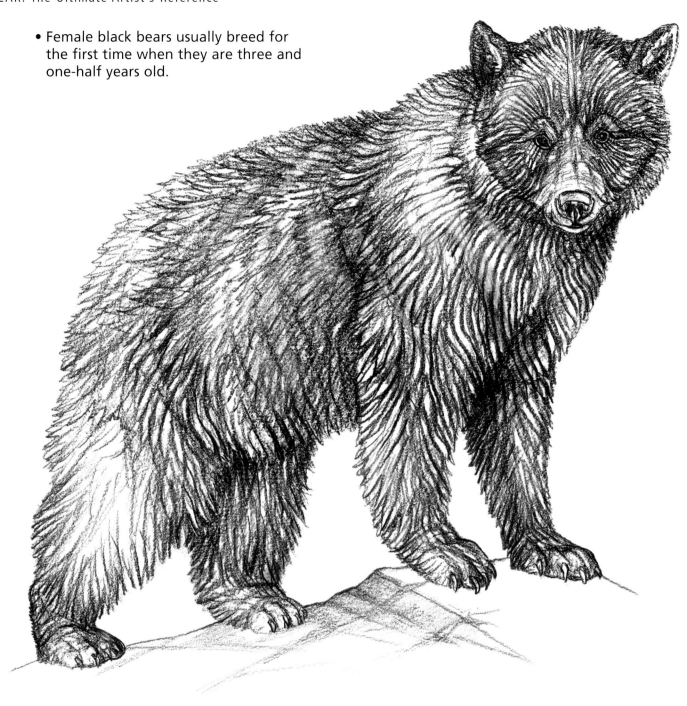

• Black bear cubs usually leave their mother when they are one and one-half years old. In the harsher climates of Alaska and Canada, the cubs may spend a second winter with their mother before leaving her and beginning life on their own.

• The majority of North America's black and brown bears den for four to six months each year. While denning (or hibernating), bears live off their fat reserves and may lose up to one-third of their body weight by spring.

• Contrary to popular belief, black bears have both a good sense of smell and good eyesight.

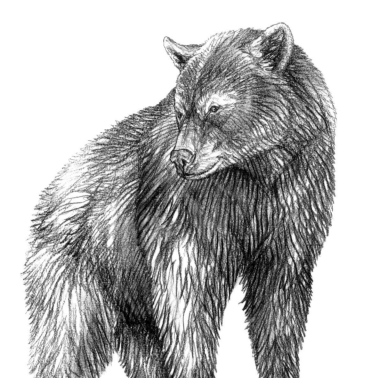

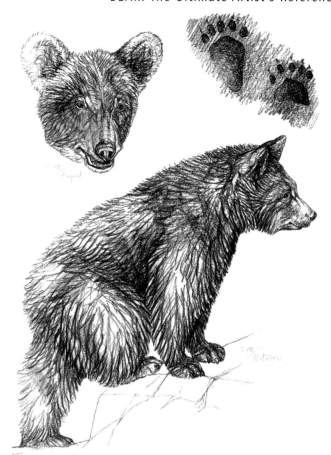

Black bear (September)

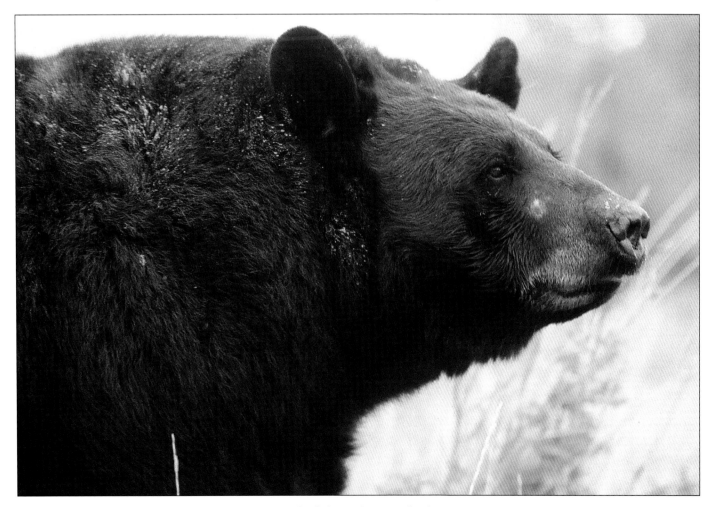

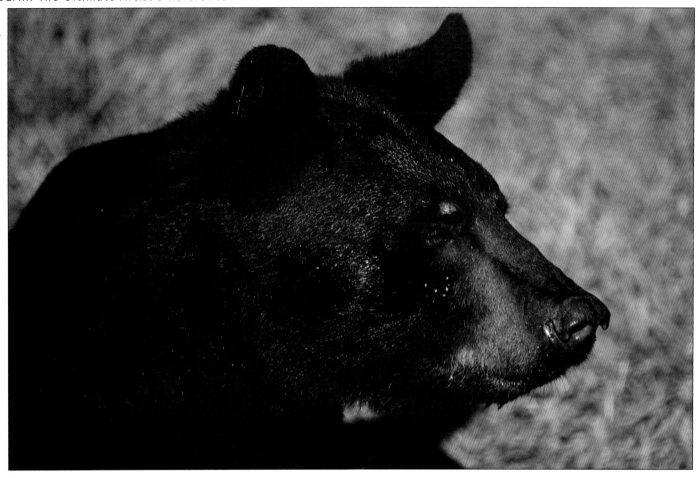

In general, brown-colored black bears are more common in open and warmer regions of North America.

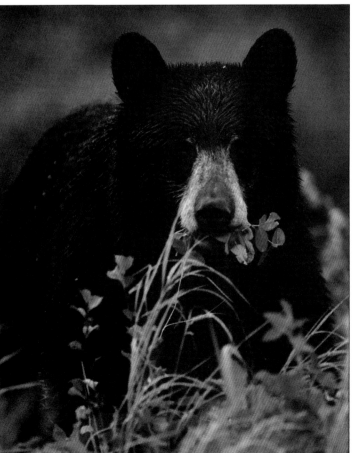

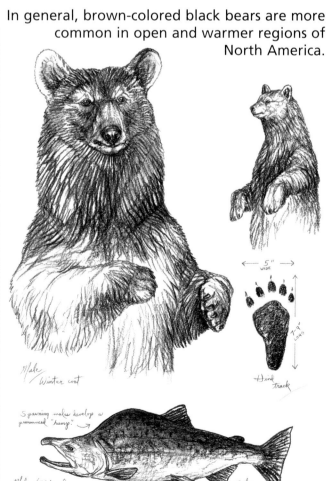

Male / Winter coat

5" wide

7-9" long

Hind track

Spawning males develop a pronounced "hump"

Male / Pink salmon

July

Black bears (September/British Columbia)

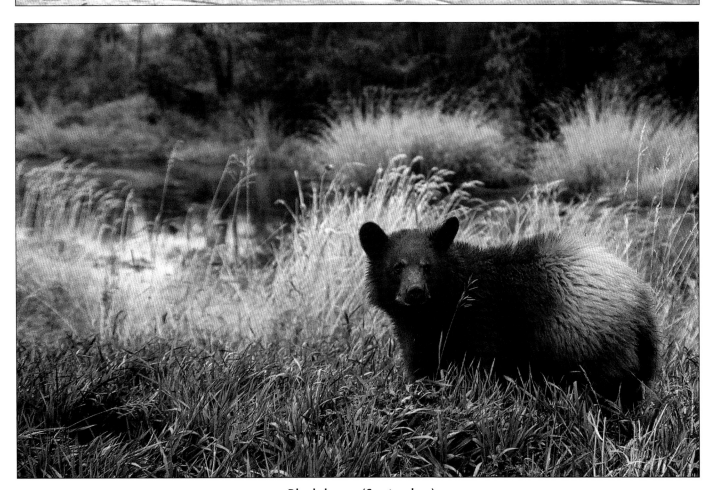

Black bears (September)

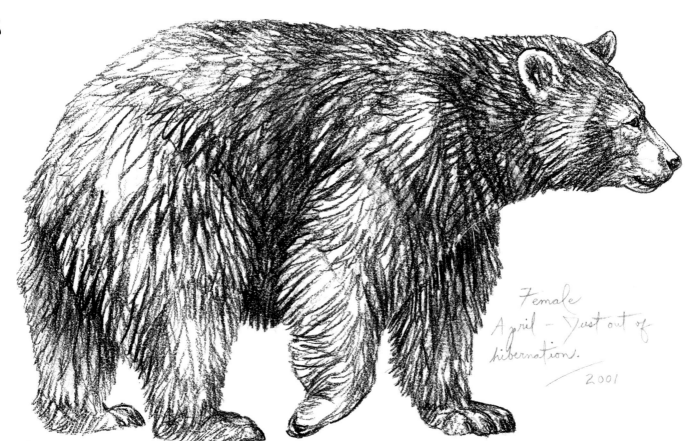

*Female
April — Just out of
hibernation.
2001*

• A spawning salmon returns to the same river system in which it was born. Its birthplace is located by smell. Of the thousands of eggs laid by adult spawning salmon, only a few survive to become adults and renew the spawning cycle. Salmon are a favorite food of bears.

*Male / Coho Salmon —
late July*

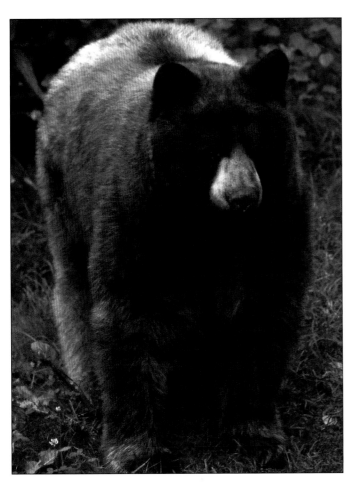

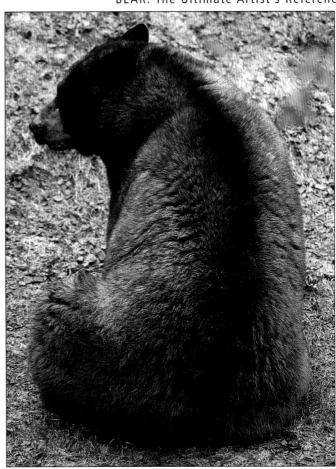

Black bears in the "Glacier" color phase of southeastern Alaska are both rare and beautiful.

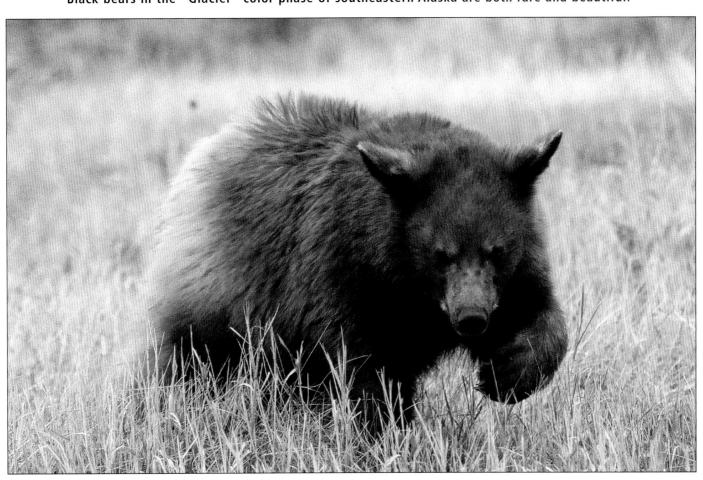

Black bear cub (September/Idaho)

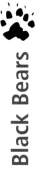

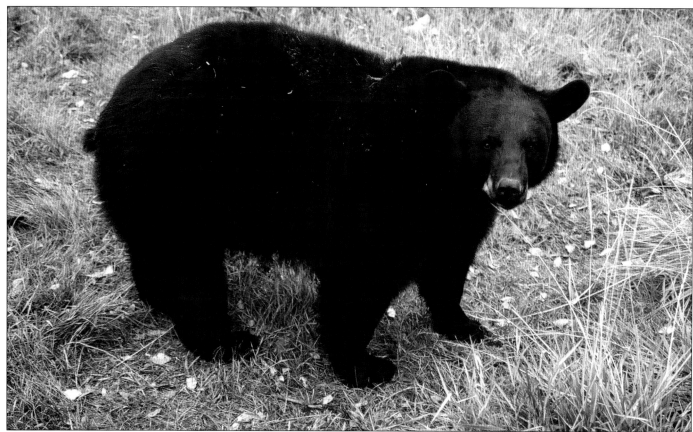

Black bear

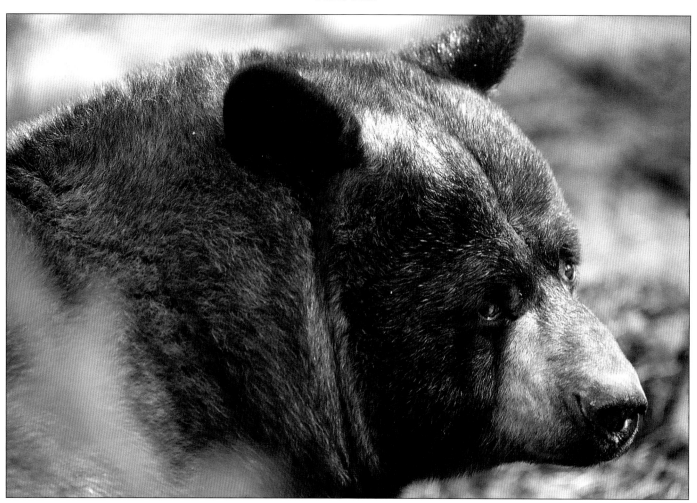

"Glacier" bear (May/Alaska)

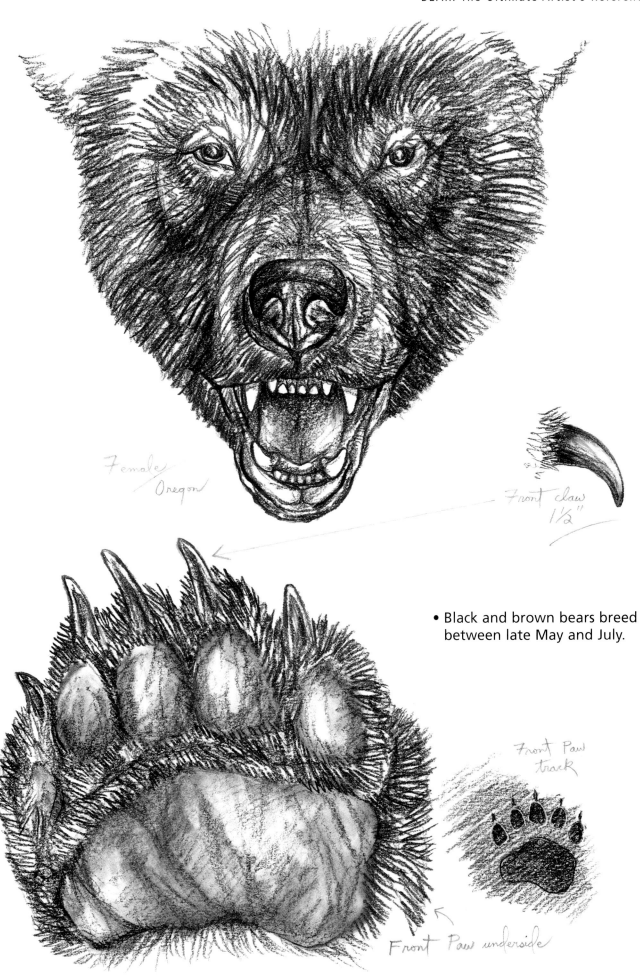

Female Oregon

Front claw 1½"

Front Paw track

Front Paw underside

• Black and brown bears breed between late May and July.

Black Bears

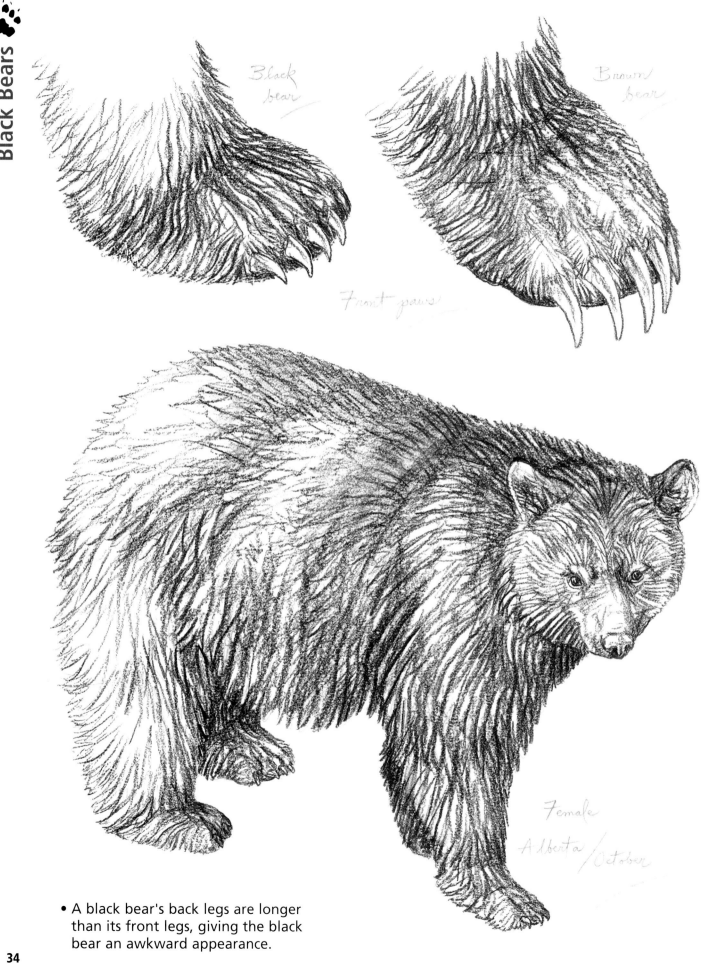

Black bear

Brown bear

Front paws

Female
Alberta / October

• A black bear's back legs are longer than its front legs, giving the black bear an awkward appearance.

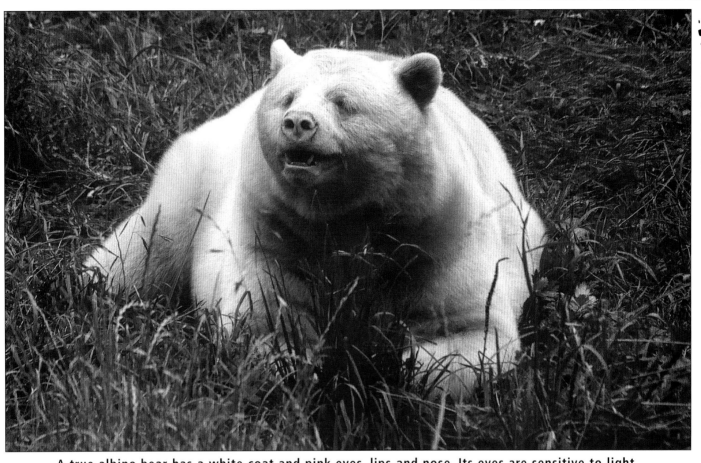

A true albino bear has a white coat and pink eyes, lips and nose. Its eyes are sensitive to light.
An albino bear will rarely survive until adulthood.

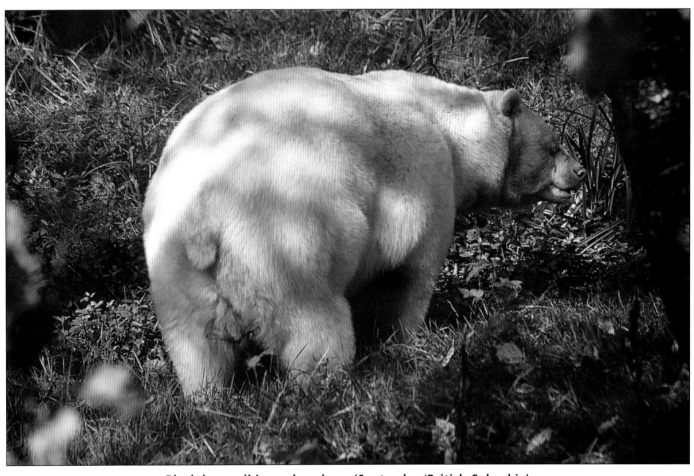

Black bear, albino color phase (September/British Columbia)

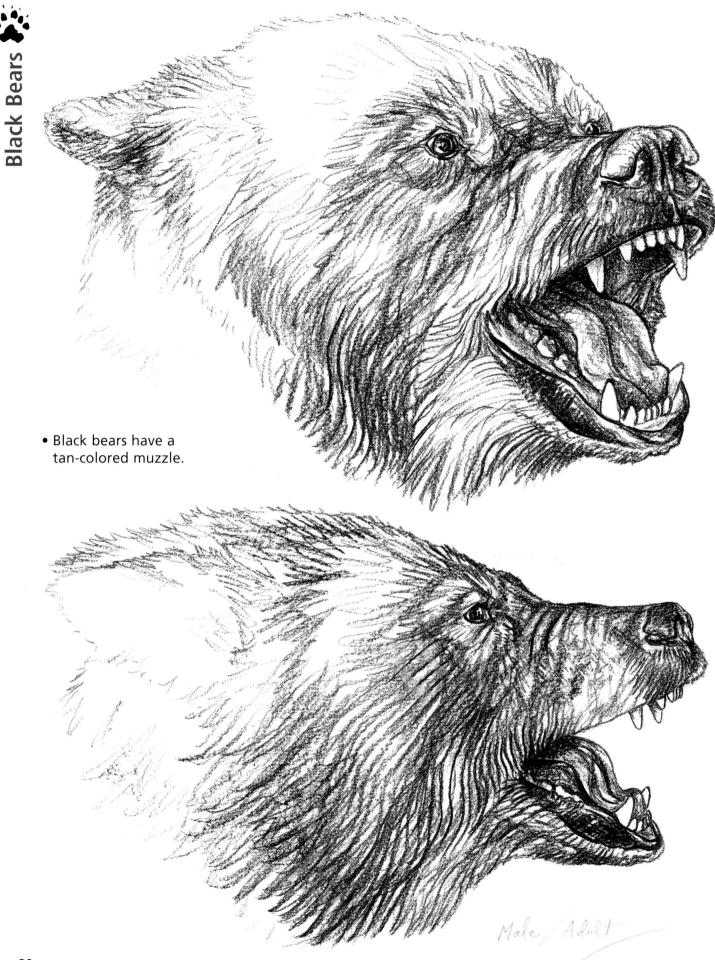

• Black bears have a tan-colored muzzle.

Male / Adult

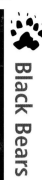

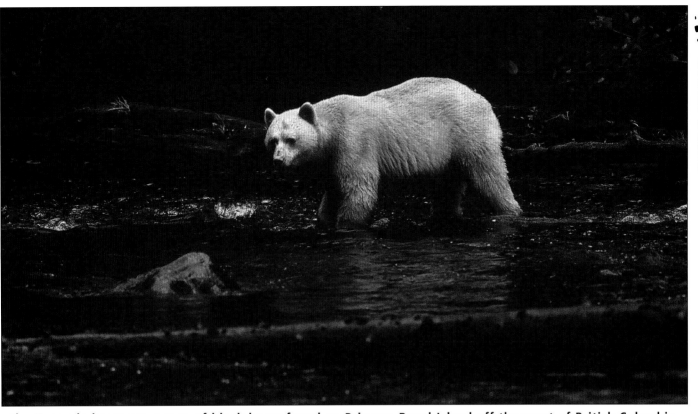

The Kermode bears are a race of black bears found on Princess Royal Island off the coast of British Columbia. Their coats are whitish, but they are not true albinos.

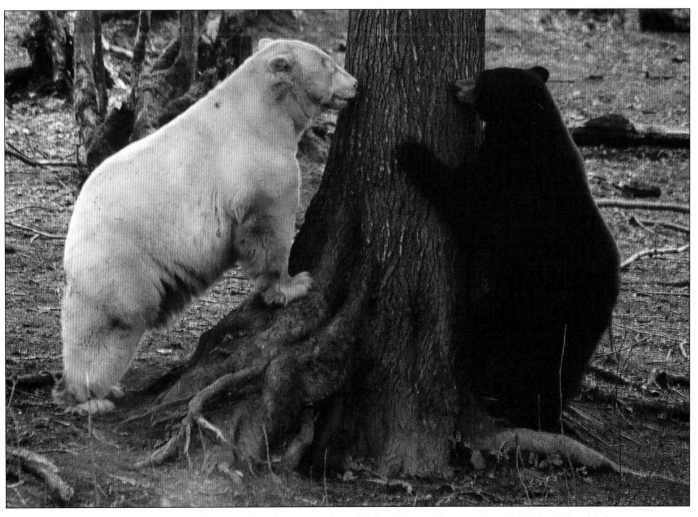

A true albino black bear with a brown-colored black bear (September/British Columbia).

Brown/Grizzly Bears

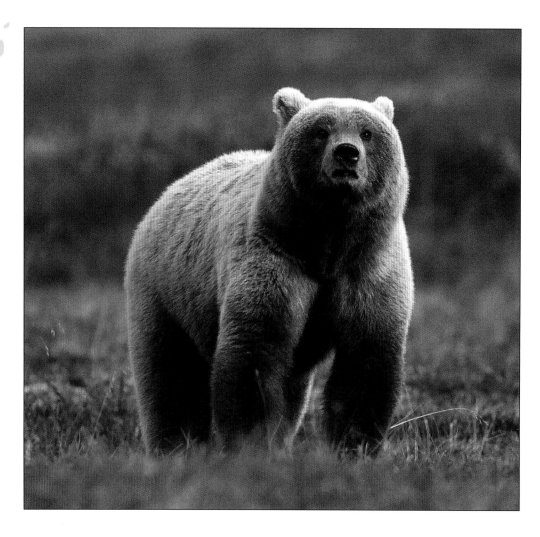

The brown bear (Ursus arctos), also known as the grizzly bear, has lost over 90 percent of its original range here in North America. In the early 1800's, the bears roamed across the continent from Alaska to Mexico. Today, however, the majority of the estimated 40,000 brown bears are confined to Alaska and Canada. Fewer than 1,000 still roam wild in the lower 48 states of America.

In Alaska, the term "brown bear" usually refers to members of the species living within 75 miles of the coast. "Grizzly" refers to those members of the species that live inland from there. Often, the terms are used interchangeably. Coastal bears are normally the largest members of Ursus arctos due mainly to the fact that they live in a salmon-rich environment. Large males can stand over eight feet tall and weigh 1,500 pounds.

Brown bears vary widely in color from almost blonde to almost black. Pregnant females den in late autumn and give birth in January and February. The cubs, which number anywhere from one to four in a litter, suckle from their hibernating mother until the family leaves their winter den in three or four months. Cubs weigh 15 to 20 pounds at this time and continue to feed on their mother's milk until they eventually begin to eat the vegetation that makes up the majority of the typical brown bears' diets.

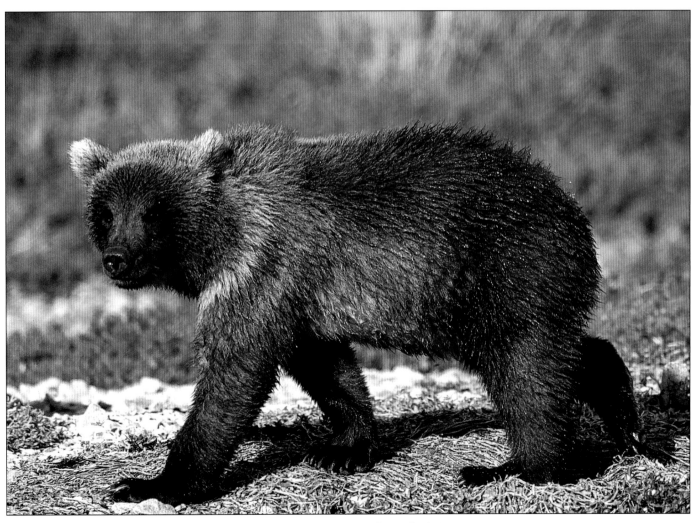

Grizzly cub (September/Alaska)

Brown/Grizzly Bears

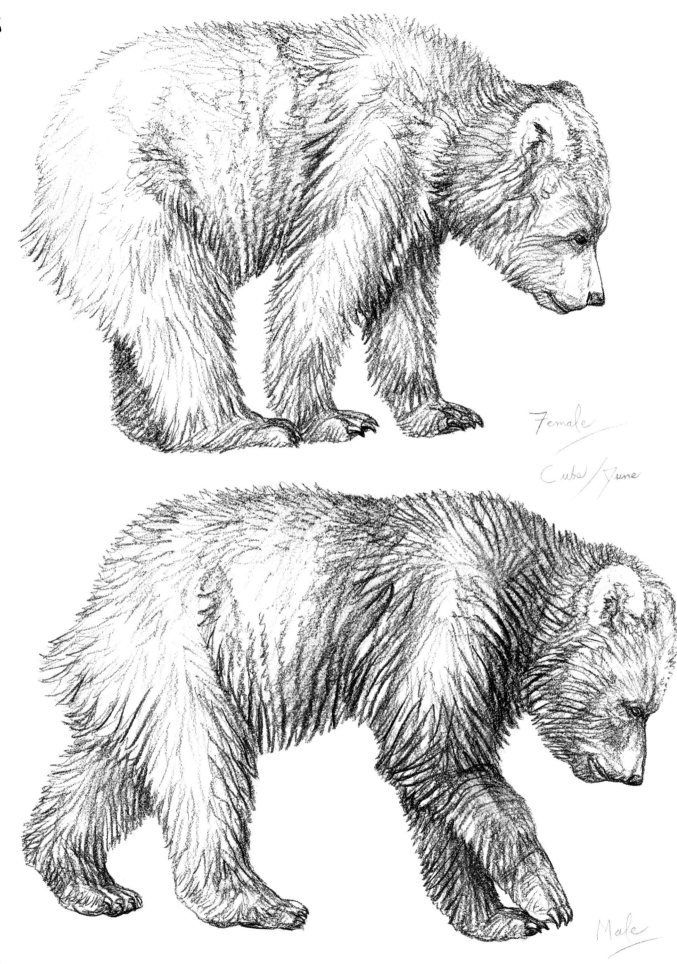

Female

Cubs/June

Male

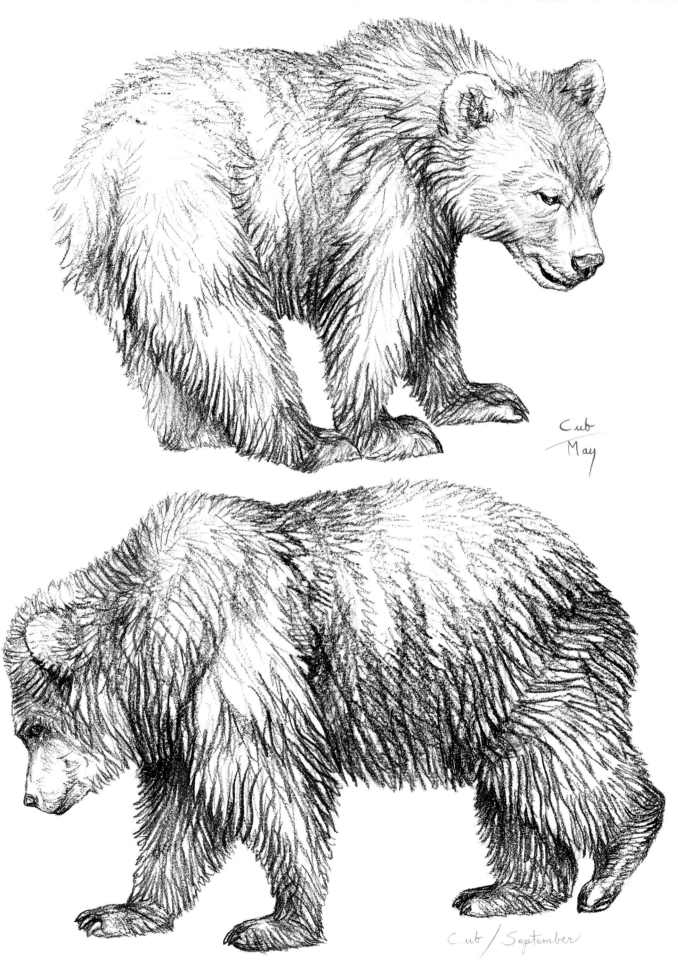

Cub
May

Cub / September

Brown/Grizzly Bears

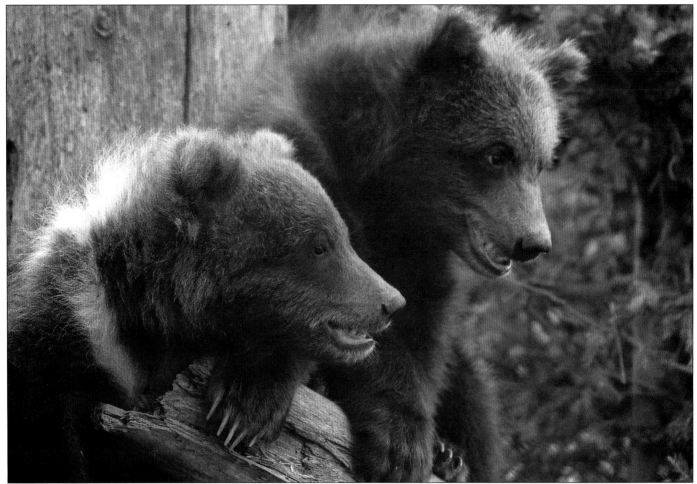

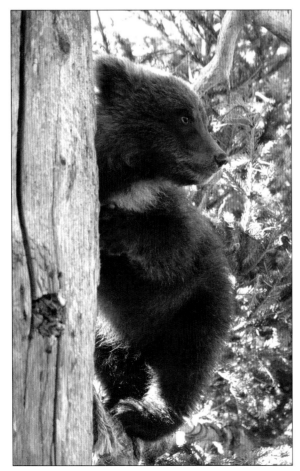

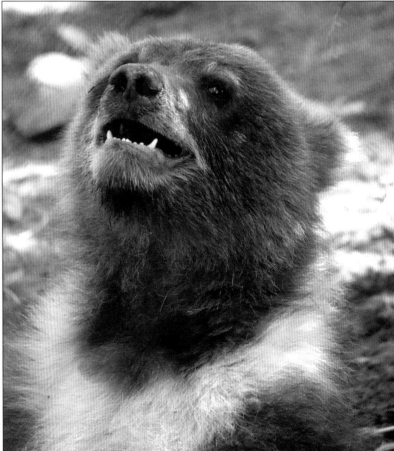

Grizzly cubs (August/Alaska). Note the white chest blaze, a common marking.

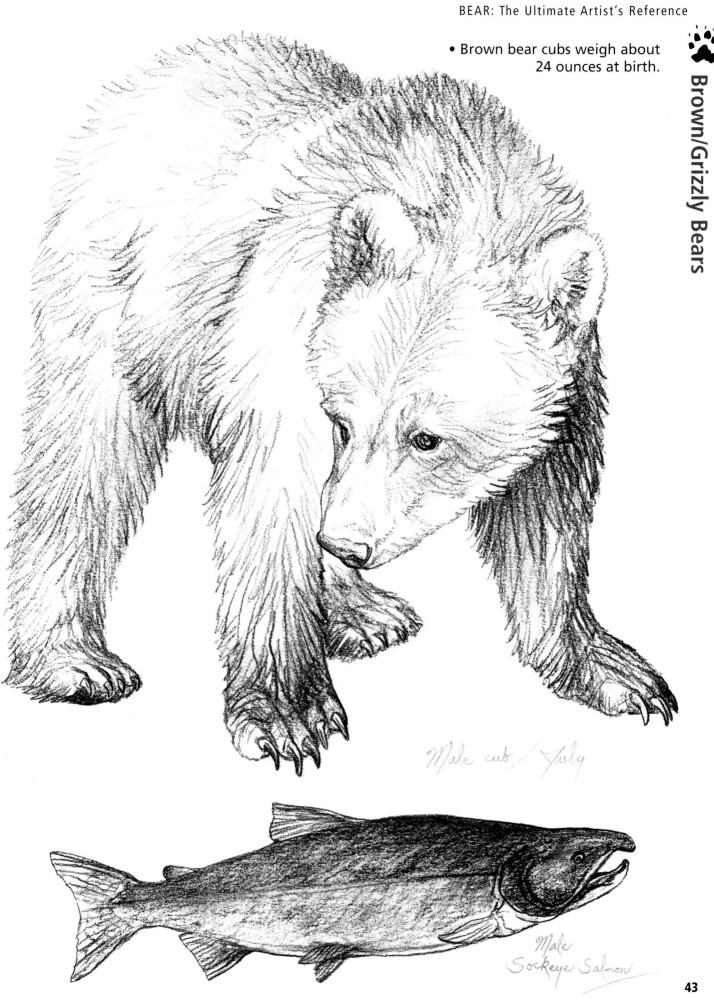

- Brown bear cubs weigh about 24 ounces at birth.

Male cub / July

Male
Sockeye Salmon

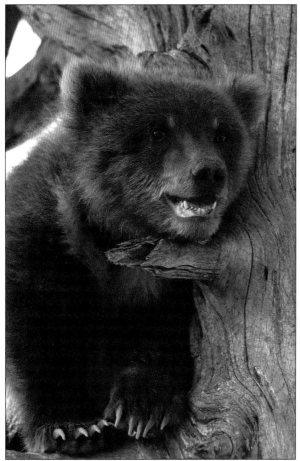
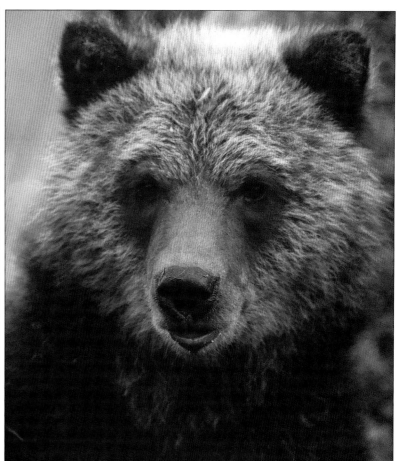

Eighteen months old (September)

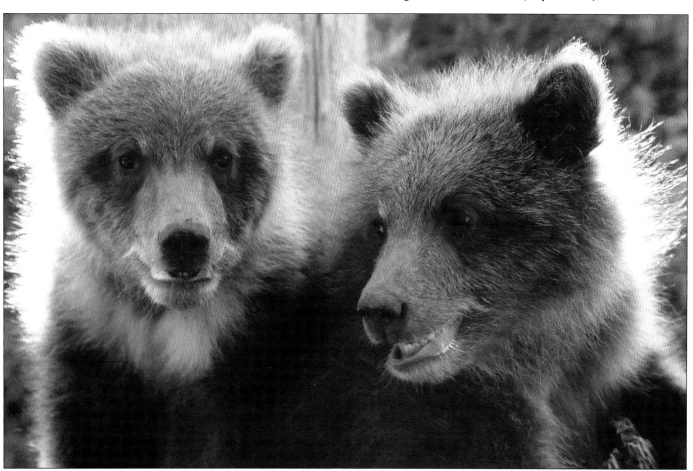

Grizzly cubs

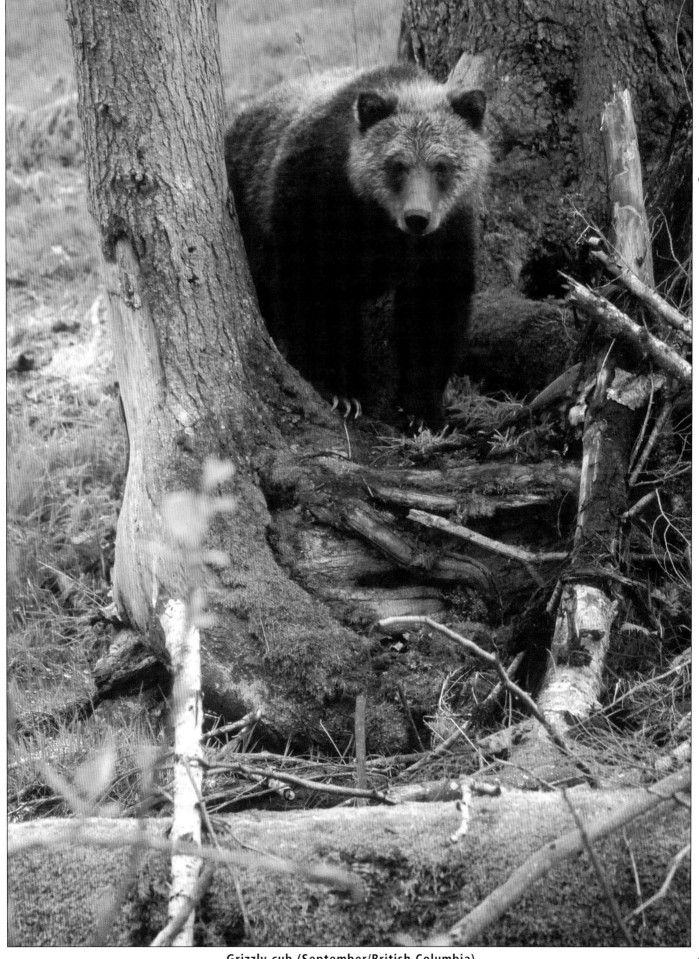

Grizzly cub (September/British Columbia)

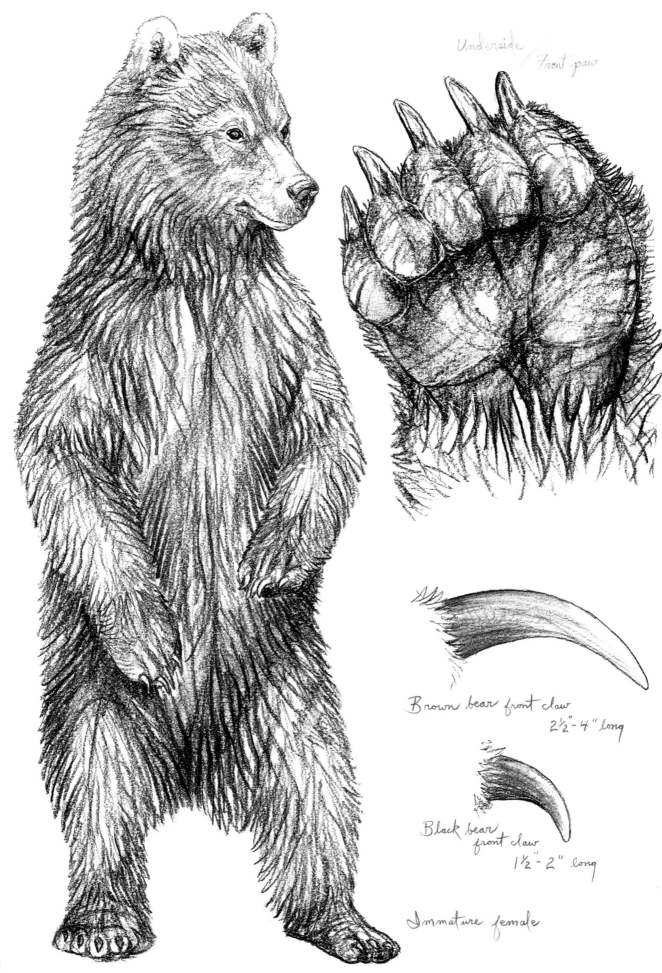

Brown/Grizzly Bears

Underside / Front paw

Brown bear front claw
2½"- 4 " long

Black bear
front claw
1½"- 2 " long

Immature female

46

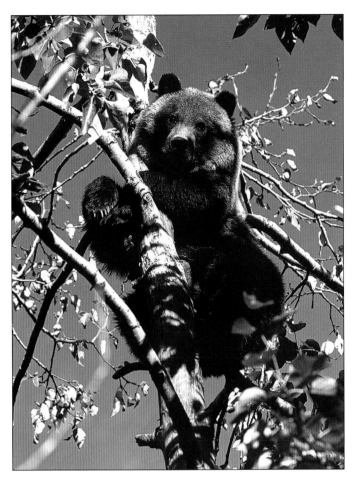

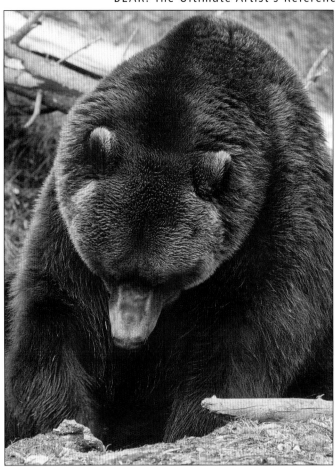

Grizzly cubs can climb trees until their large weight prevents this activity.
This cub is about 20 feet high in the tree (August/Alaska).

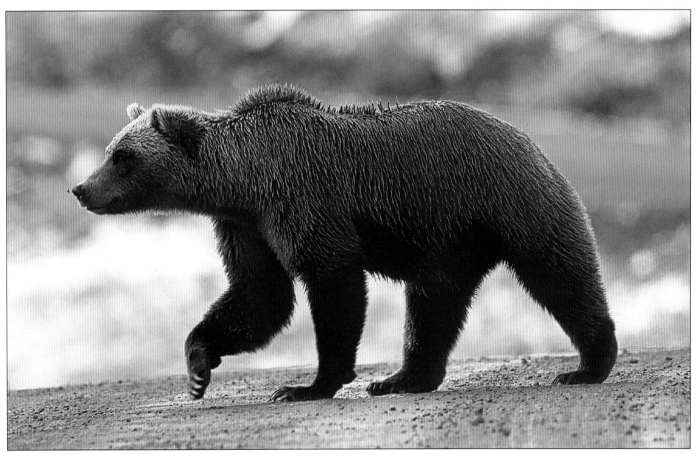

Grizzly bear (September/Denali National Park, Alaska)

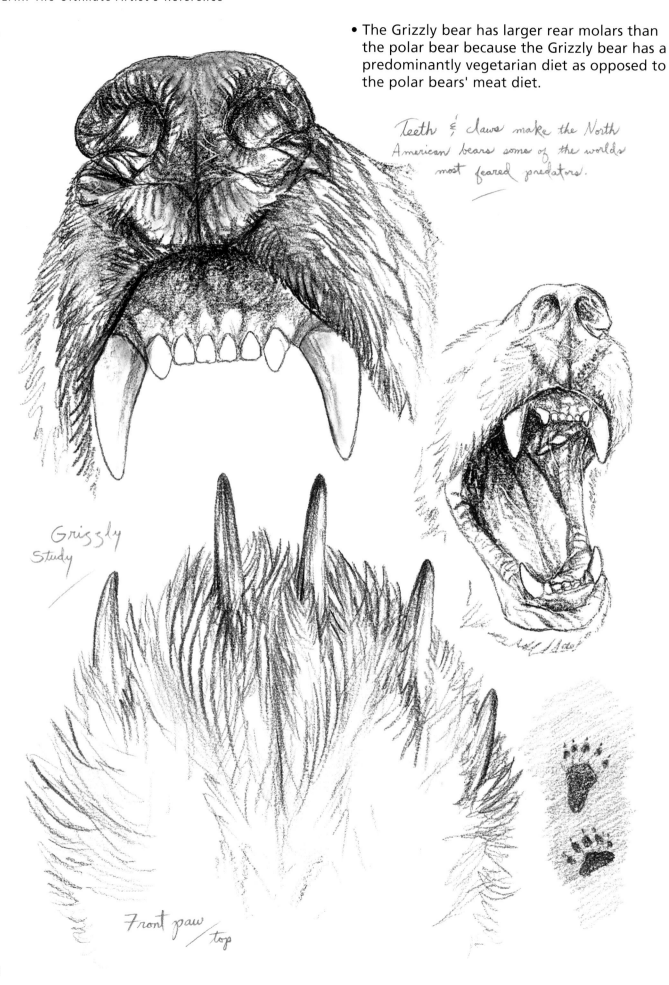

Brown/Grizzly Bears

• The Grizzly bear has larger rear molars than the polar bear because the Grizzly bear has a predominantly vegetarian diet as opposed to the polar bears' meat diet.

Teeth & claws make the North American bears some of the worlds most feared predators.

Grizzly Study

Front paw/top

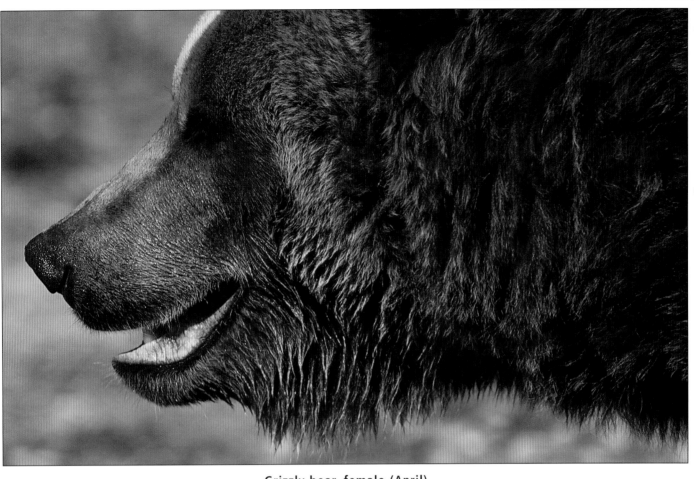

Grizzly bear, female (April)

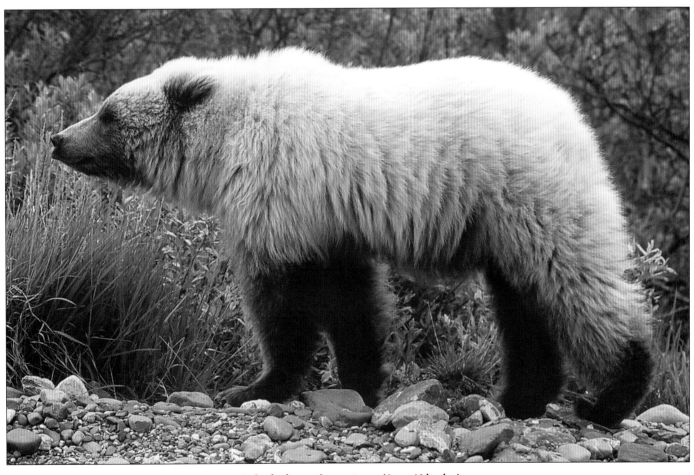

Grizzly bear, immature (June/Alaska)

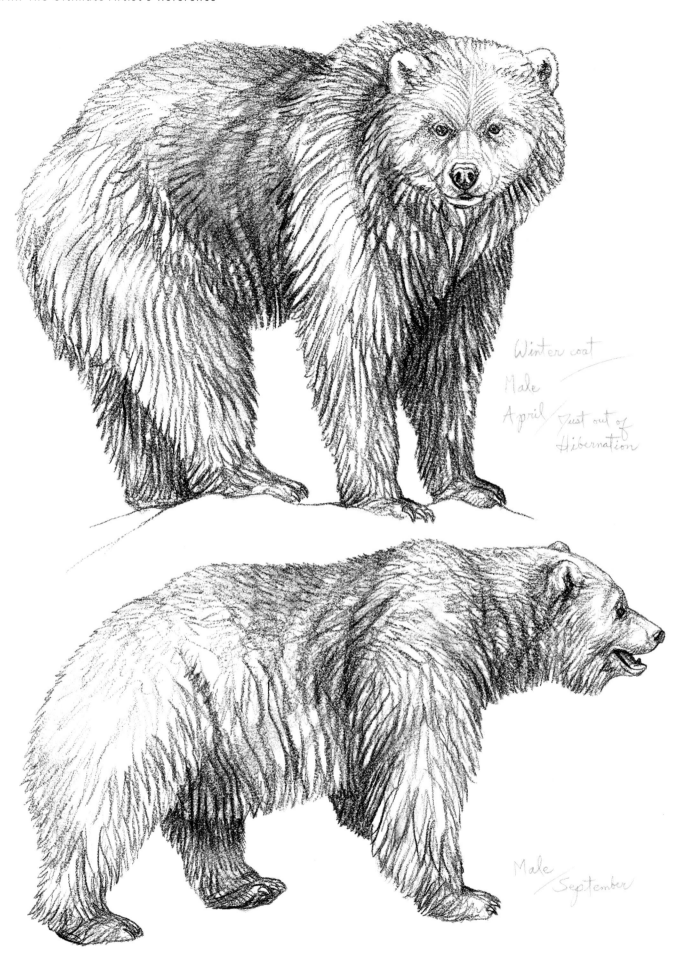

Winter coat
Male
April / Just out of
Hibernation

Male
September

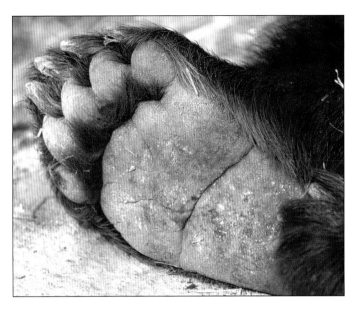

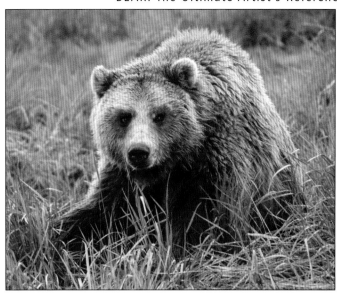

Bears walk on the soles of their feet, as humans do, not on their toes, as most other carnivores do.
A bear walks with its front feet toe-in.

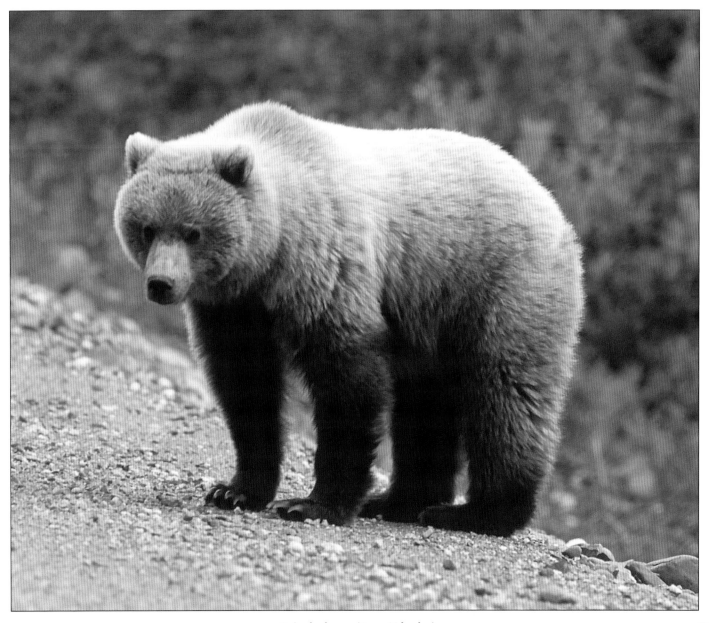

Grizzly bear (June/Alaska)

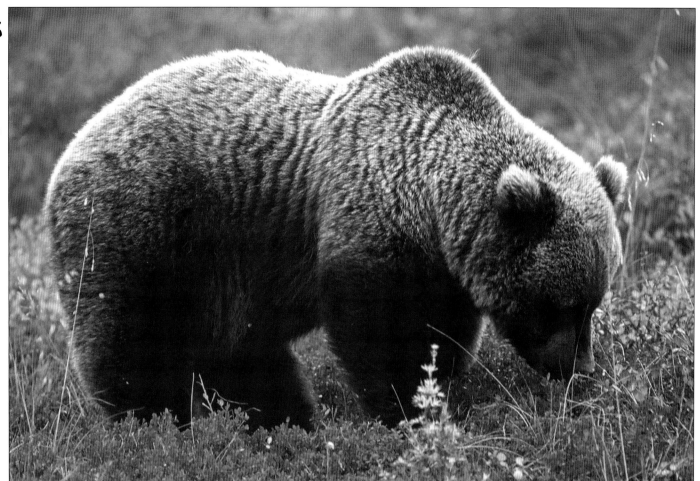

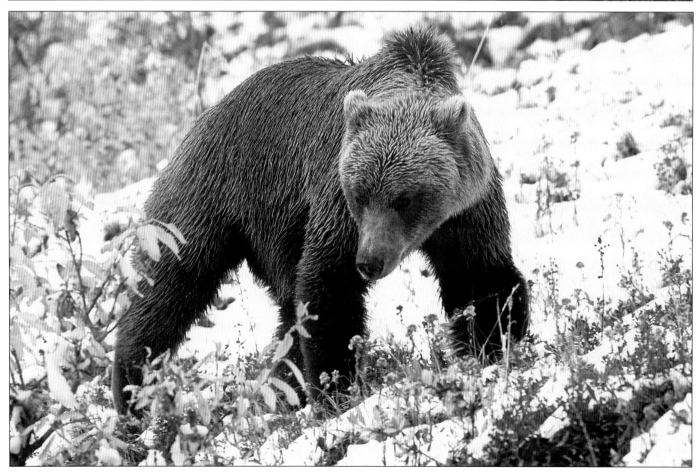

Grizzly bears (September/Denali National Park, Alaska}

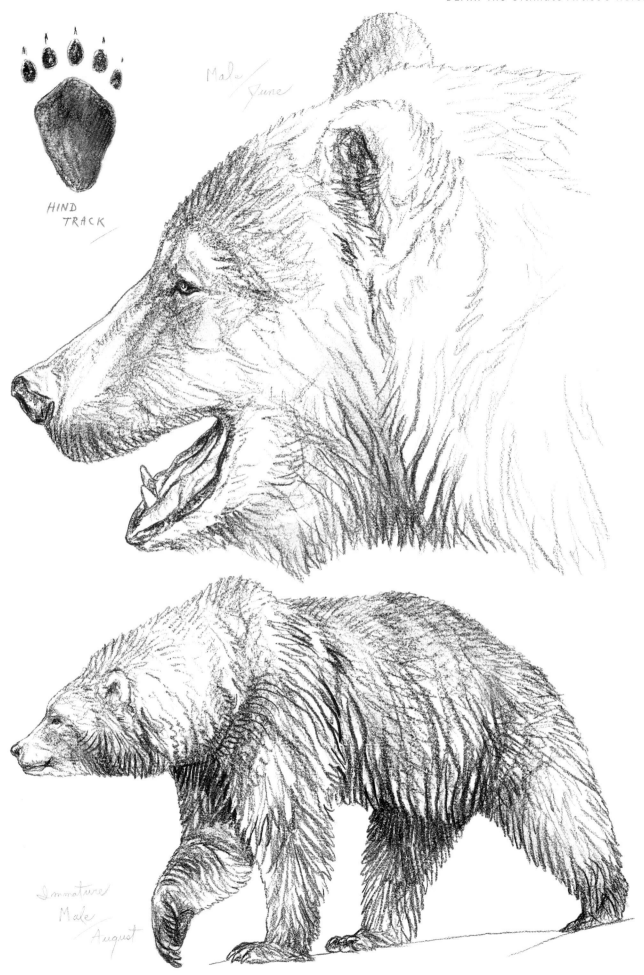

HIND
TRACK

Male/June

Immature
Male
August

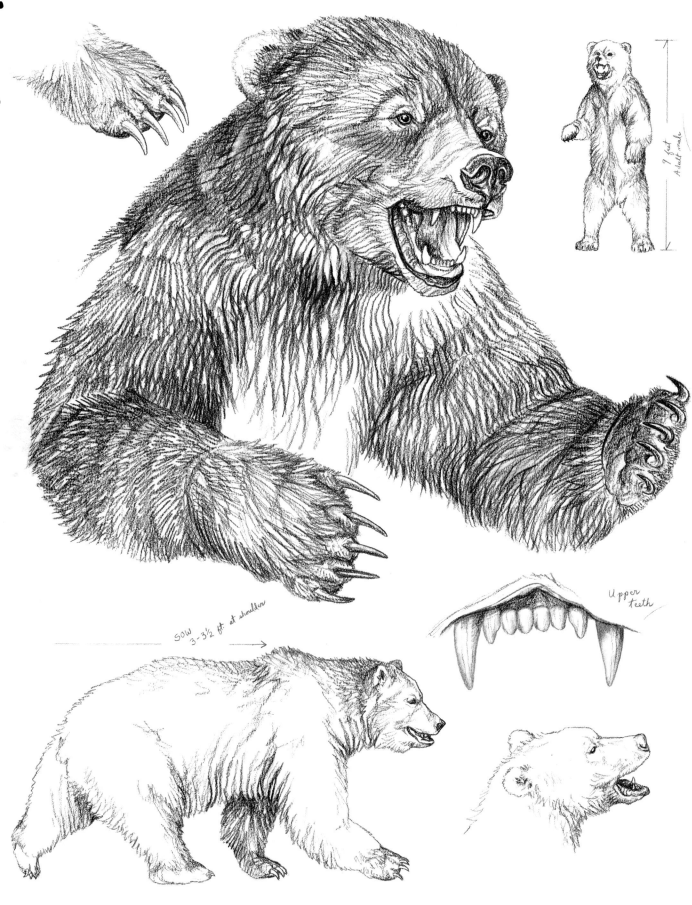

9 feet
Adult male

Upper teeth

SOW
3-3½ ft at shoulder

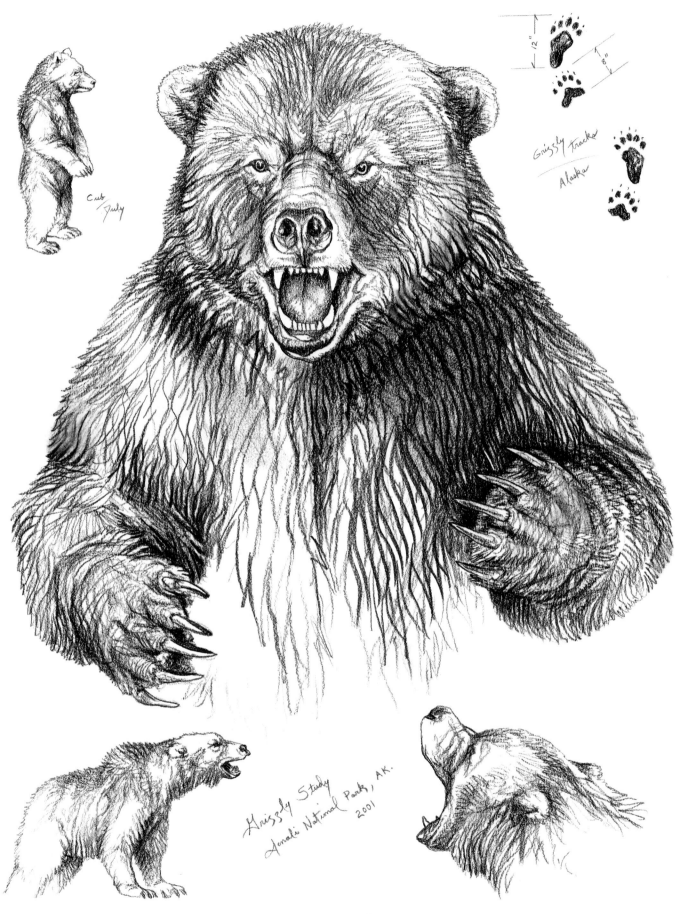

Cub July

Grizzly Tracks
Alaska

12"

8"

Grizzly Study
Denali National Park, AK.
2001

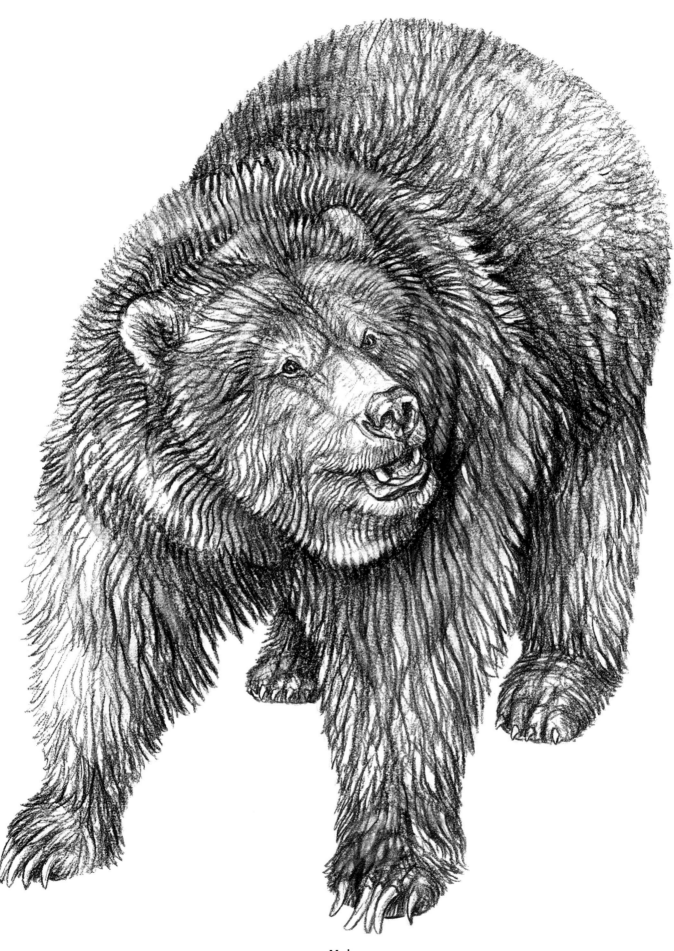

Male

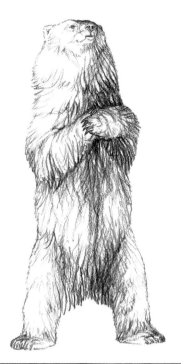

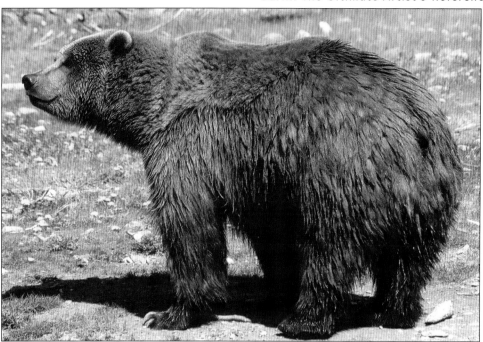

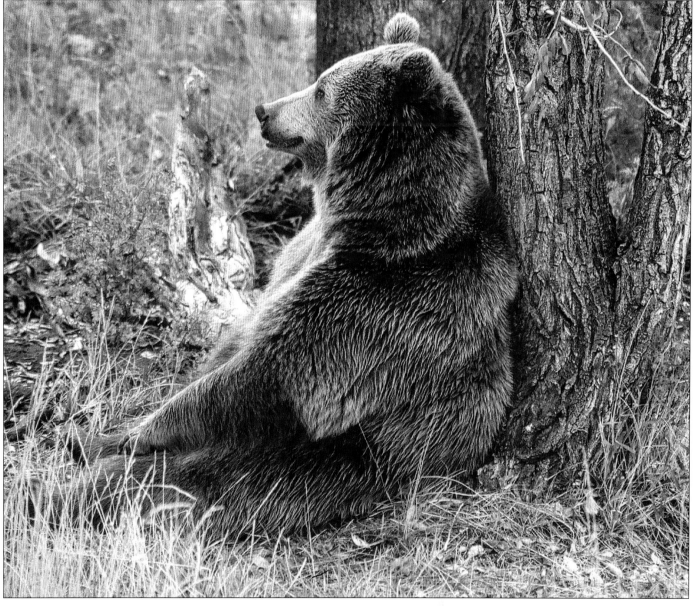

Brown/Grizzly bears

Brown/Grizzly Bears

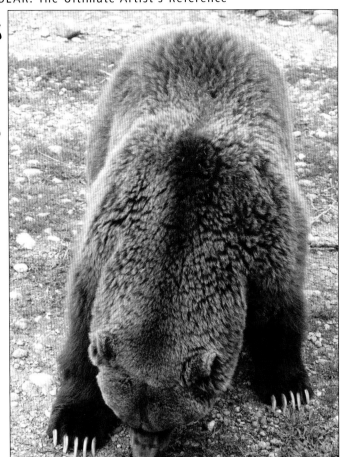

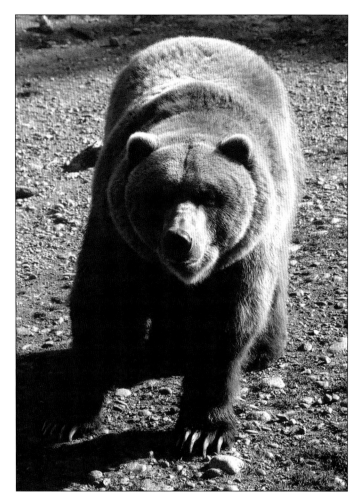

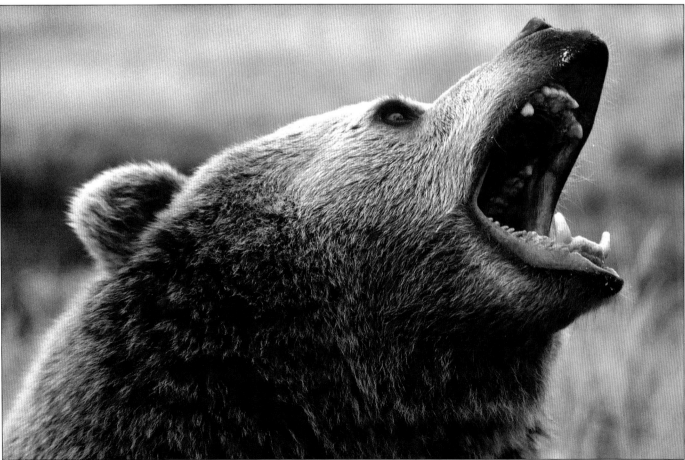

Brown/Grizzly bears

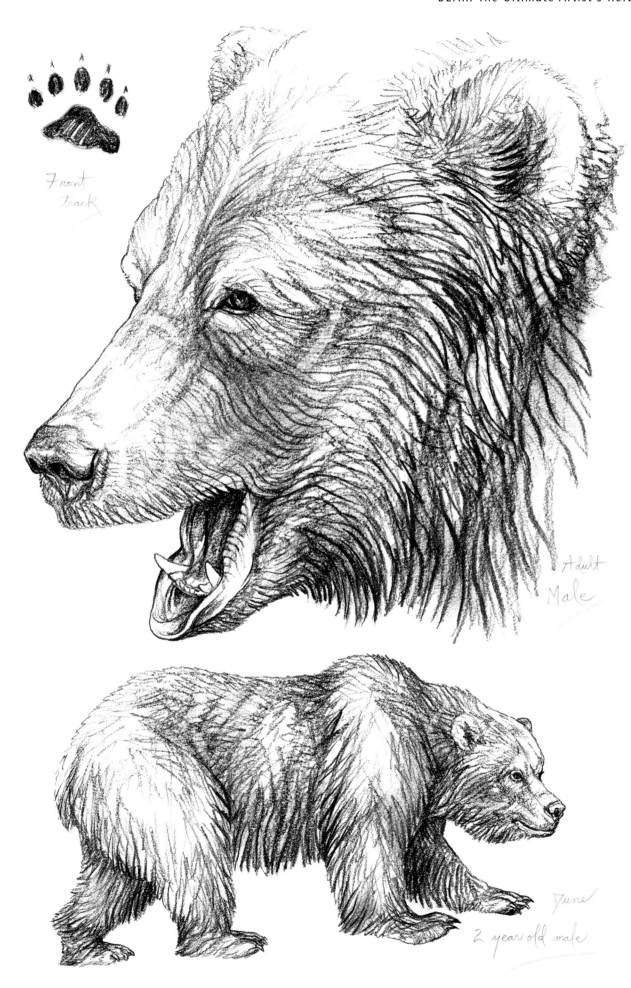

Front track

Adult Male

June

2 year old male

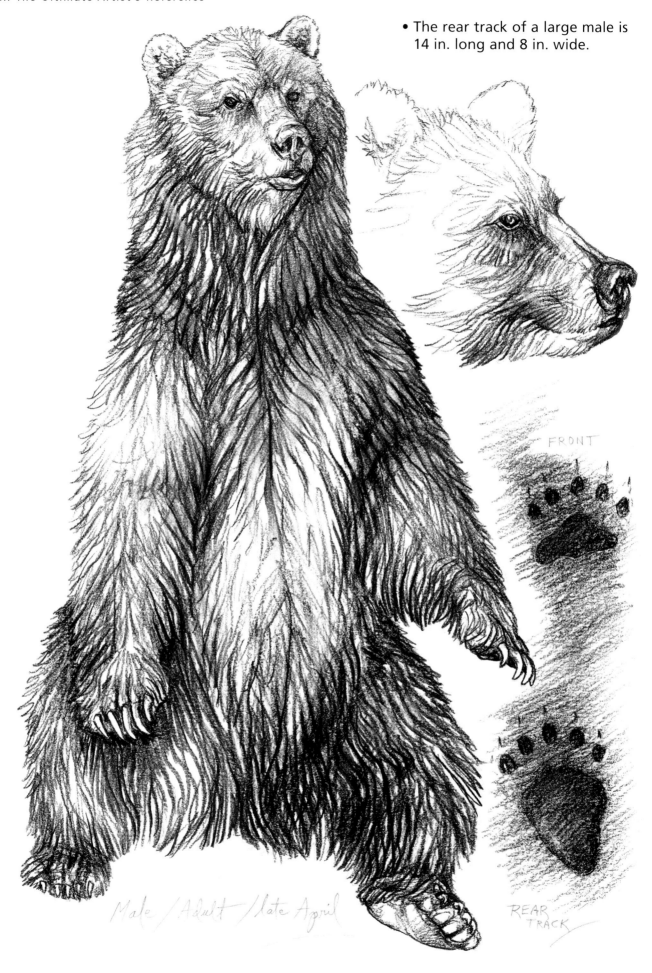

• The rear track of a large male is 14 in. long and 8 in. wide.

FRONT

Male /Adult /late April

REAR TRACK

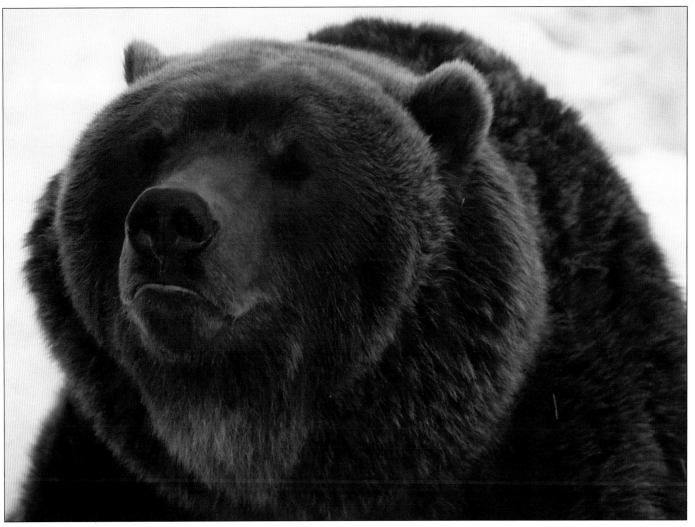

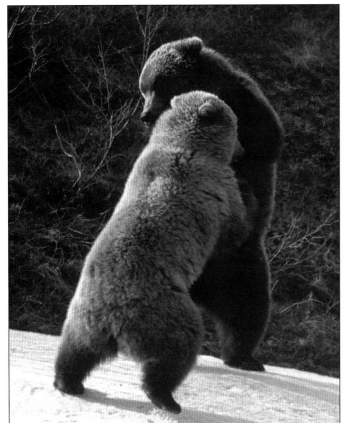

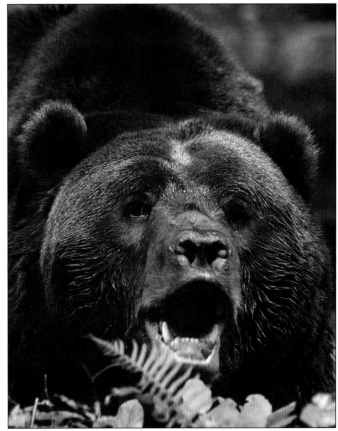

Brown/Grizzly bears (April/May)

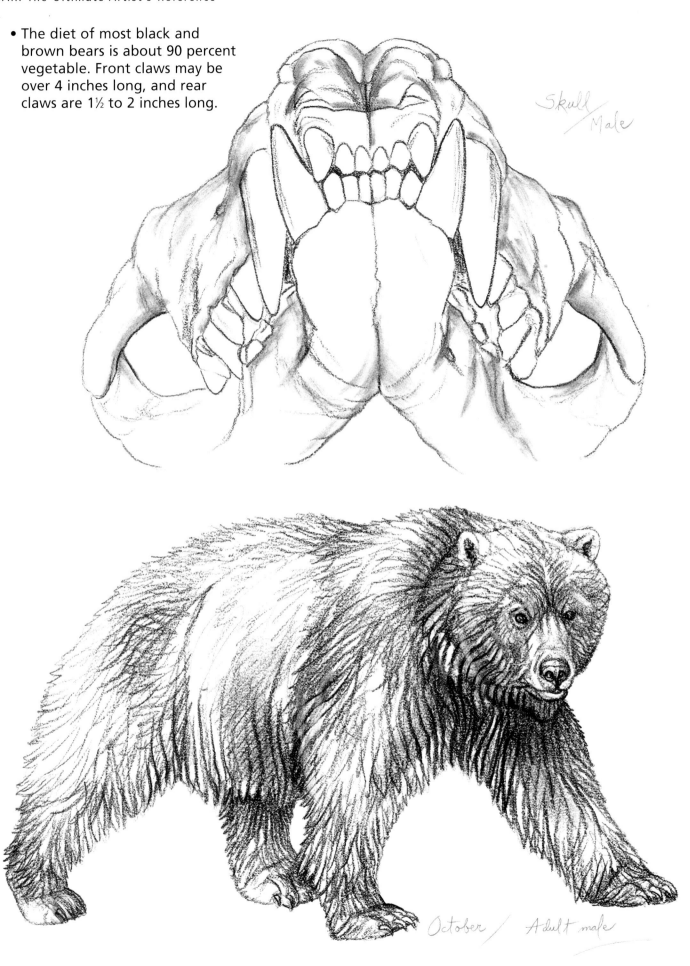

Brown/Grizzly Bears

• The diet of most black and brown bears is about 90 percent vegetable. Front claws may be over 4 inches long, and rear claws are 1½ to 2 inches long.

Skull/Male

October / Adult male

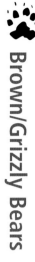

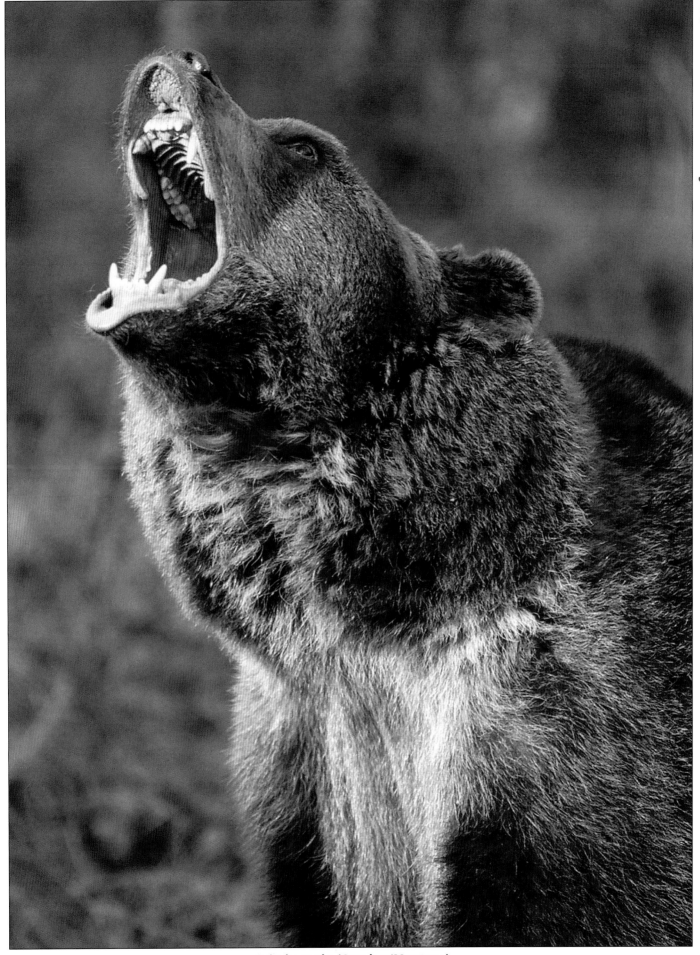

Grizzly, male (October/Montana)

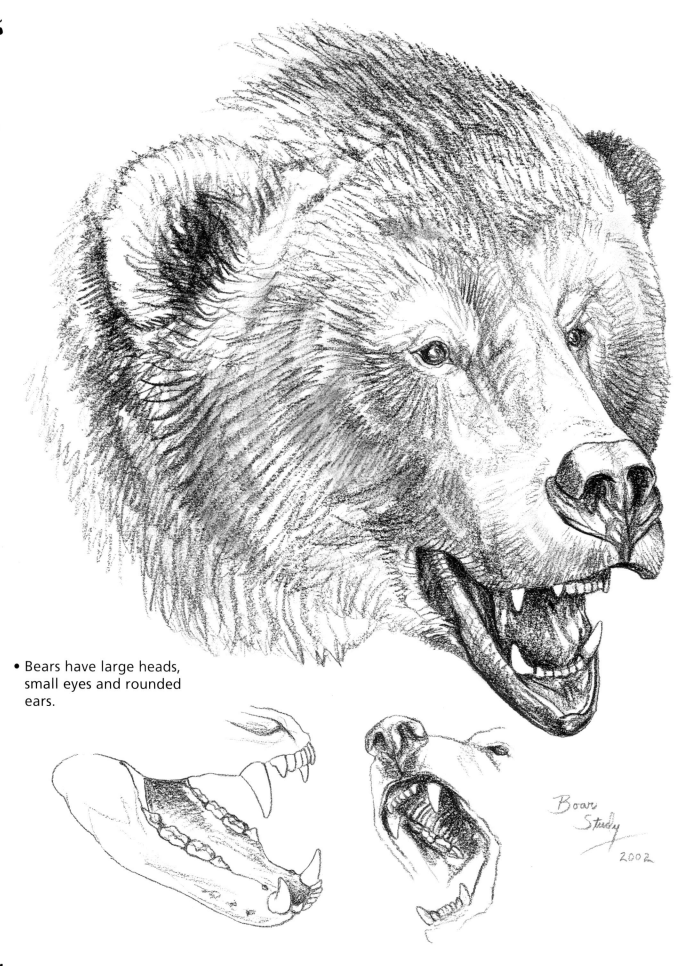

• Bears have large heads, small eyes and rounded ears.

Boars
Studly
2002

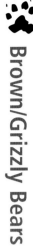

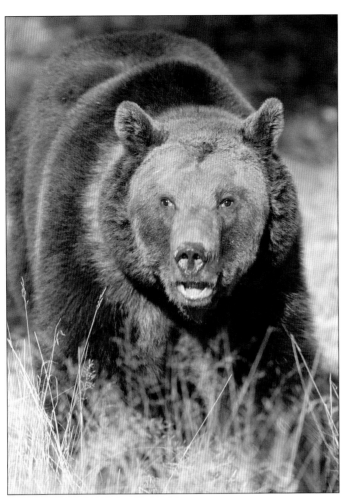

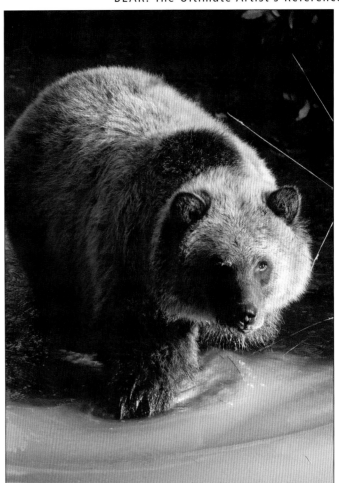

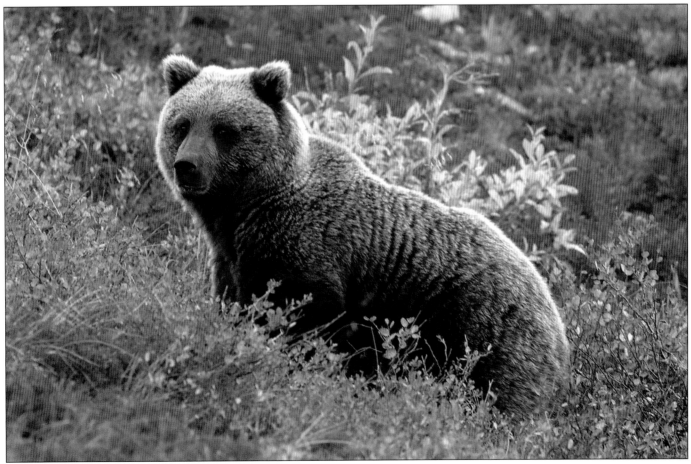

Grizzly bears (September)

Brown/Grizzly Bears

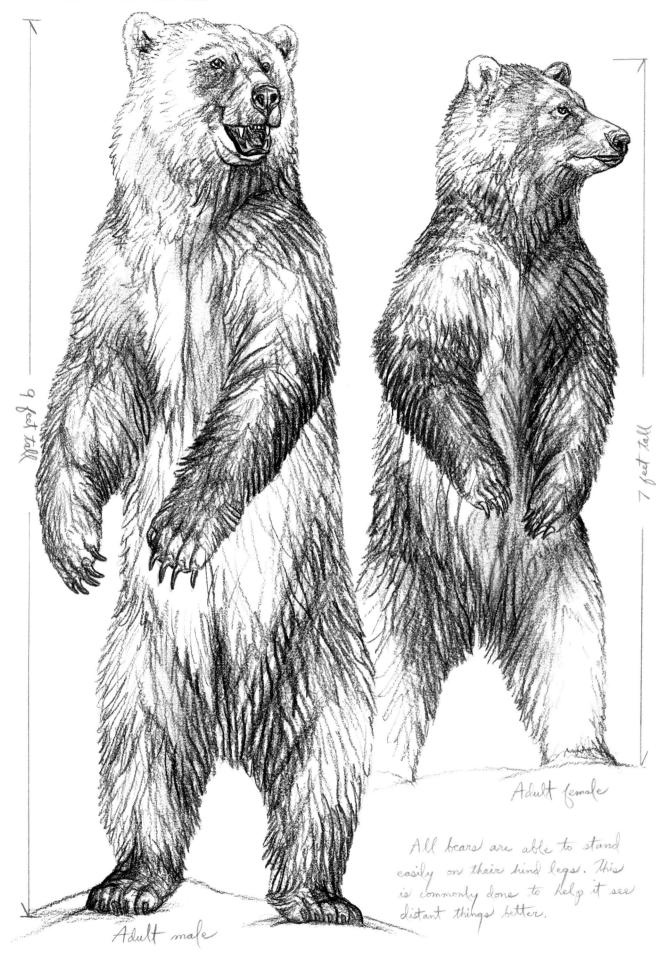

9 feet tall

7 feet tall

Adult female

Adult male

All bears are able to stand easily on their hind legs. This is commonly done to help it see distant things better.

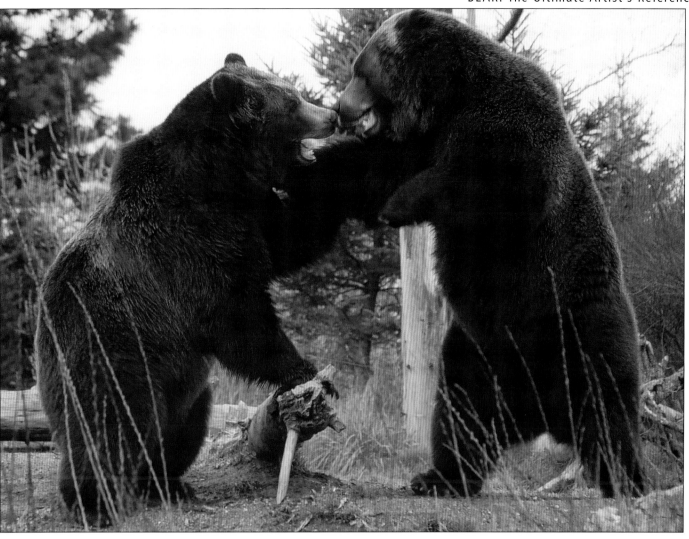

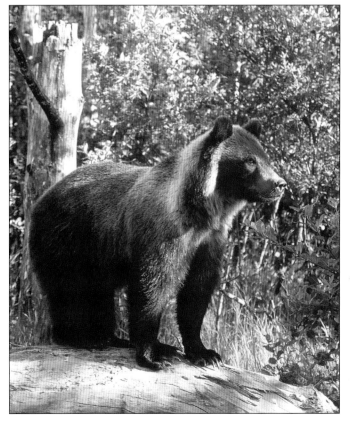

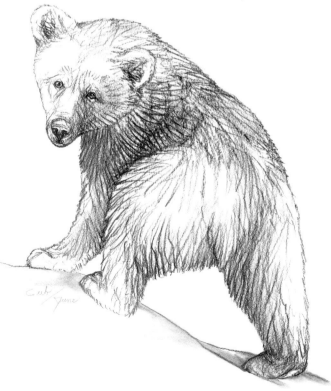

Grizzly bears (August)

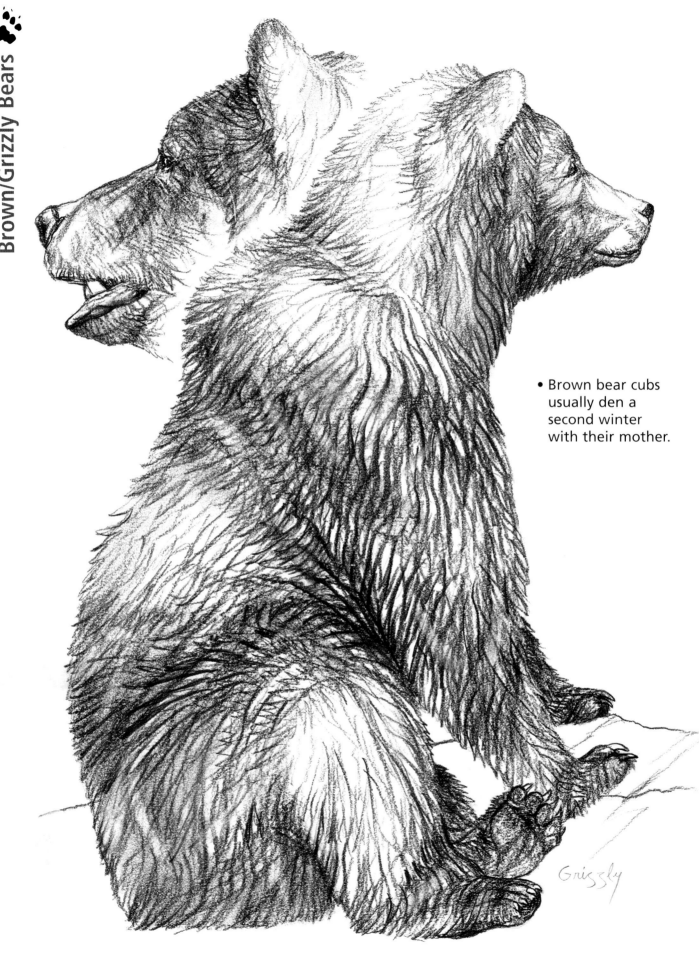

• Brown bear cubs usually den a second winter with their mother.

Grizzly

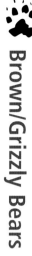

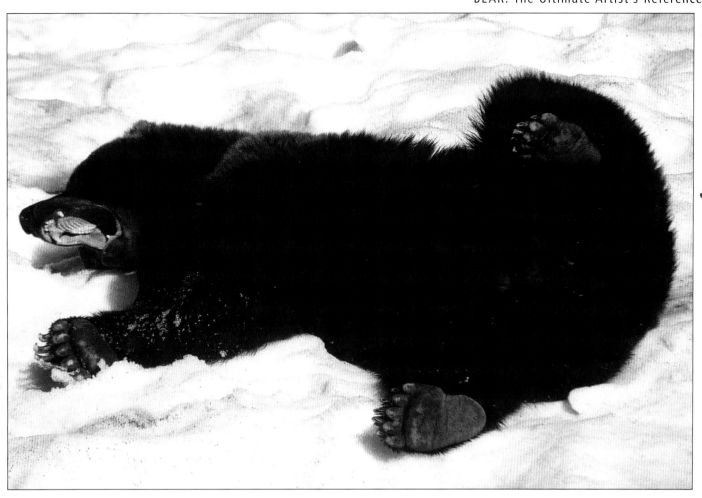

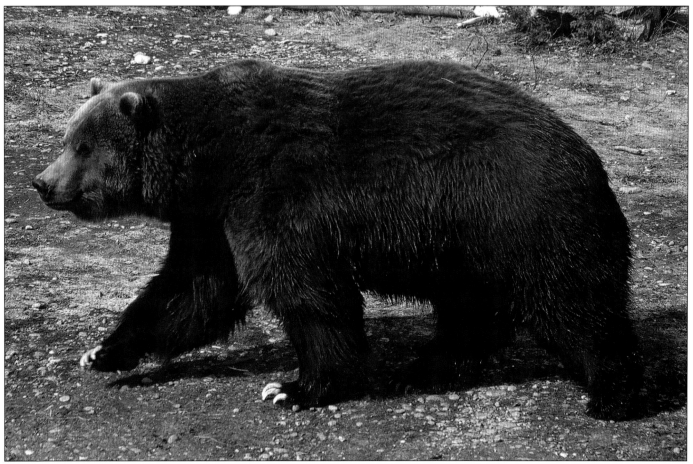

Brown/Grizzly bears (May/Alaska)

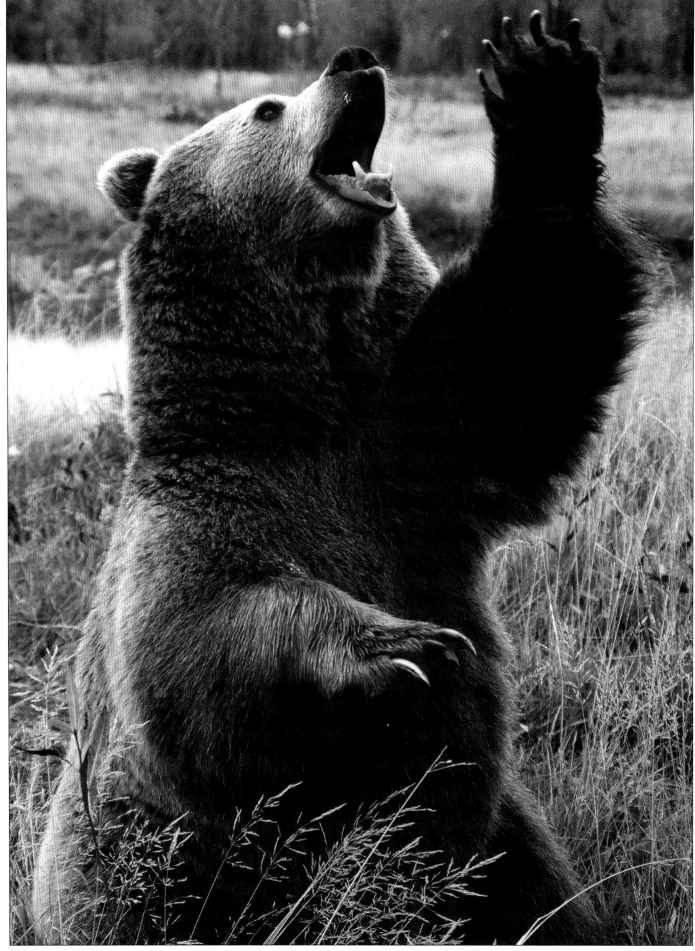

Grizzly (October)

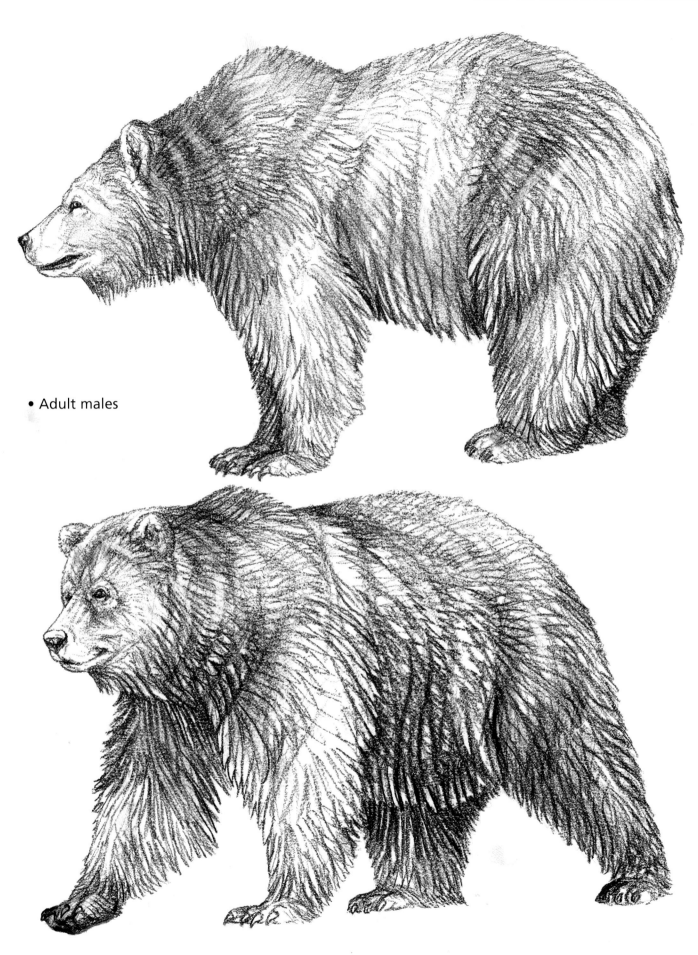

• Adult males

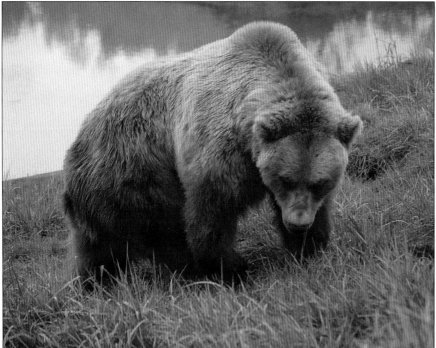

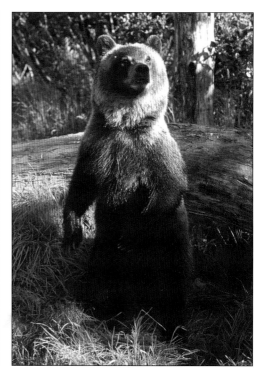

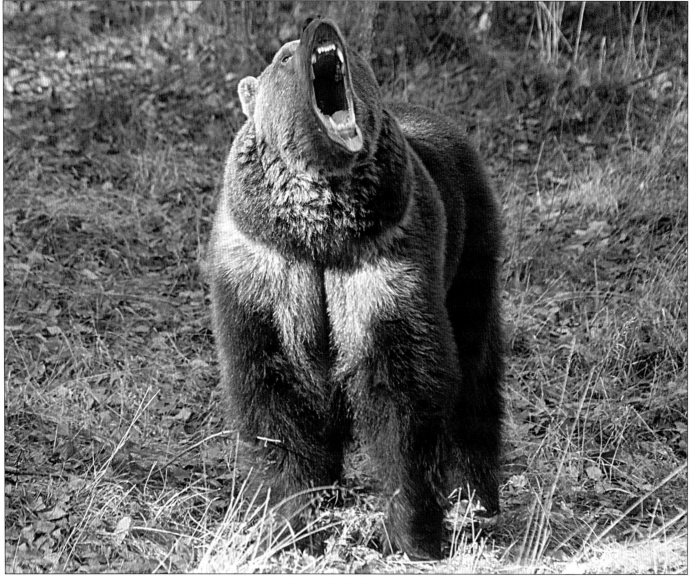

Brown/Grizzly bears

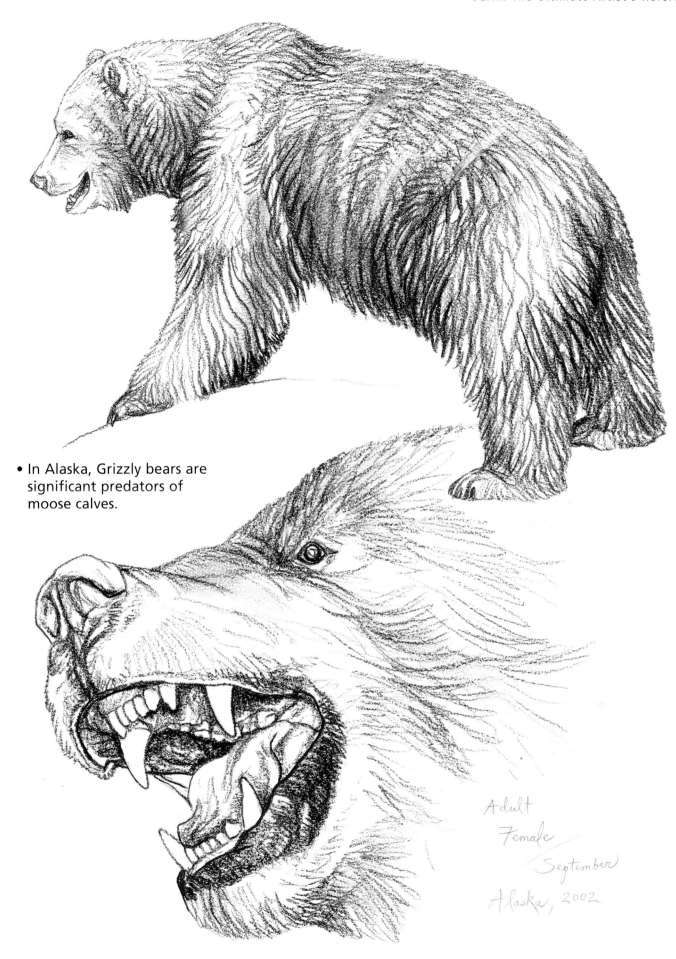

• In Alaska, Grizzly bears are significant predators of moose calves.

Adult
Female
September
Alaska, 2002

Brown/Grizzly Bears

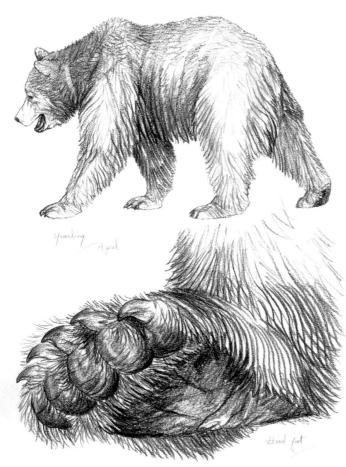

Yearling
April

Hind foot

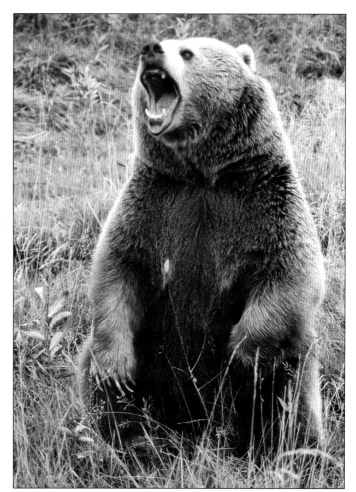

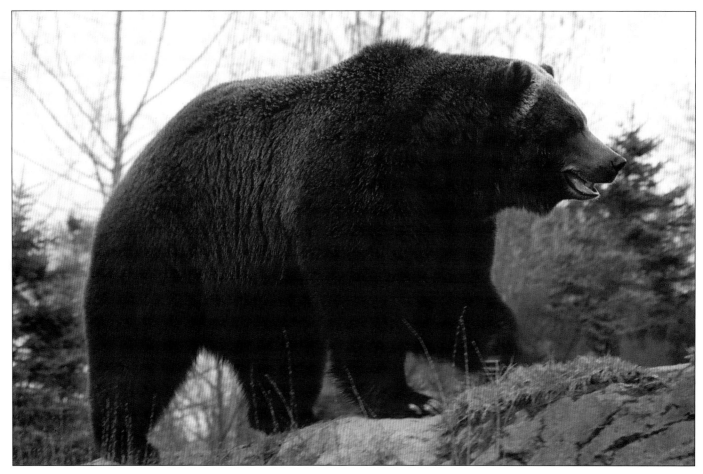

Brown/Grizzly bears (October/Canada)

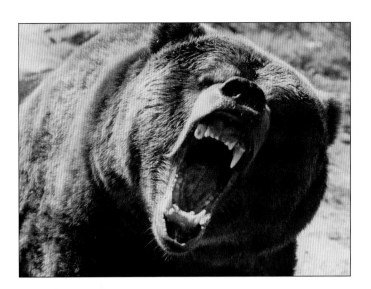

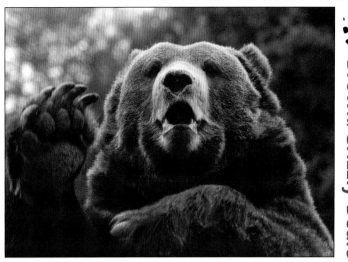

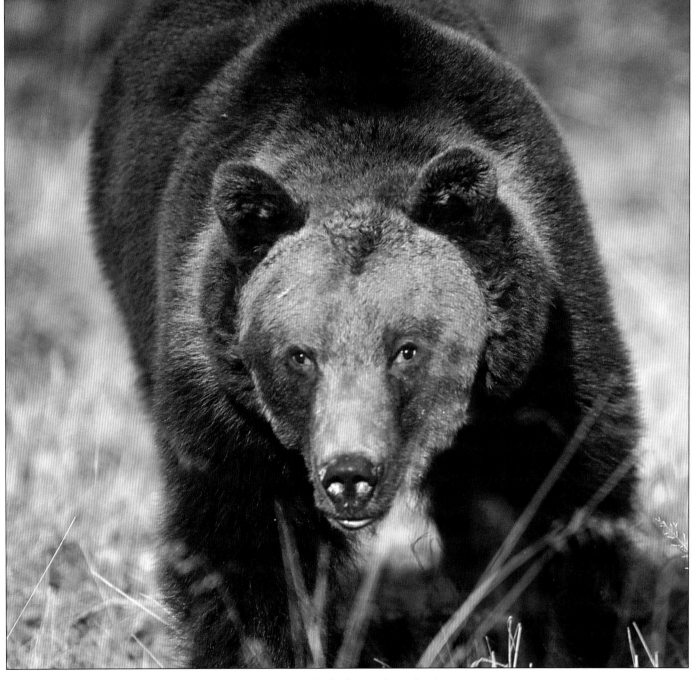

Brown/Grizzly bears (October)

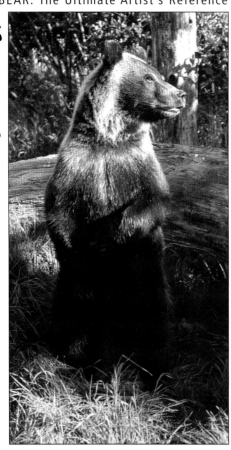

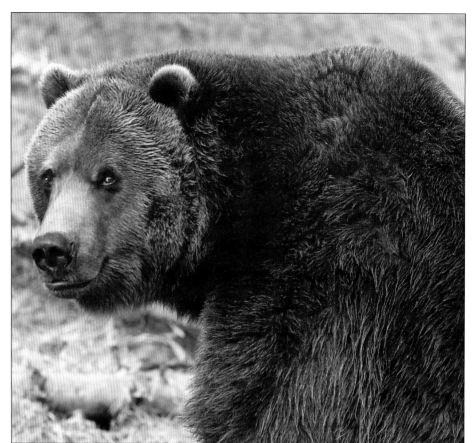

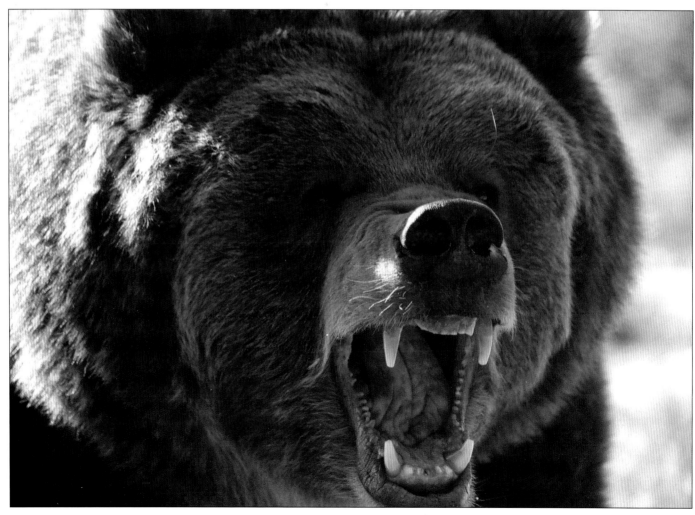

Brown/Grizzly bears (August/September)

Polar Bears

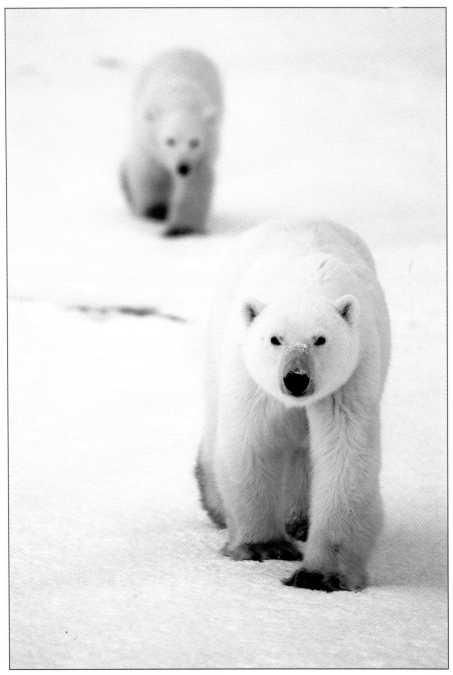

Polar Bears

The polar bear's scientific name is Ursus maritimus. This "sea bear" inhabits the far north and lives much of its life on the ever-shifting ice of the Arctic seas. It is white to light yellow in color and sports a black nose, as well as black lips, eyes, tongue and claws. It is arguably the largest of all bears-- a large adult male can stand over 10 feet tall and weigh over 1,600 pounds. A mature female is normally about one-half to two-thirds this size.

Scientists estimate that there are about 30,000 to 40,000 polar bears worldwide, and their population is divided into about seven core groups around the Arctic. Mating normally occurs in April and May, and the denning female gives birth from November to January. These cubs, numbering from one to four, will stay with their mother for about two years before she abandons her young to breed again.

The polar bear is predominantly a meat eater, and its diet consists mainly of seal, walrus and carrion. Polar bears are a source of hides and food for the Arctic's native people.

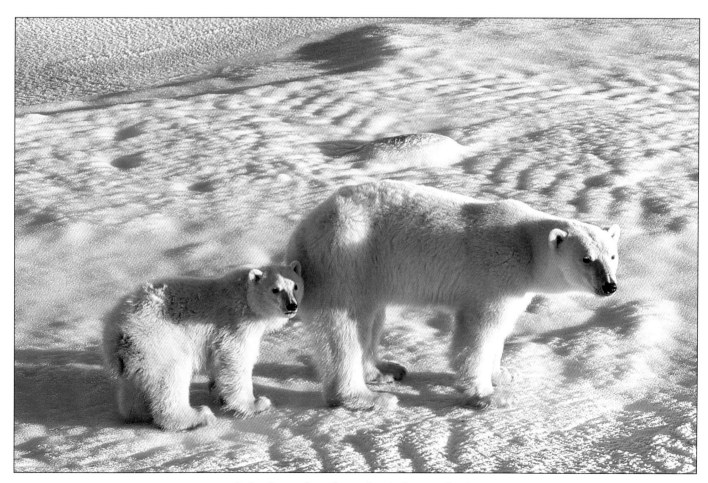

Polar bear, female and cub (November)

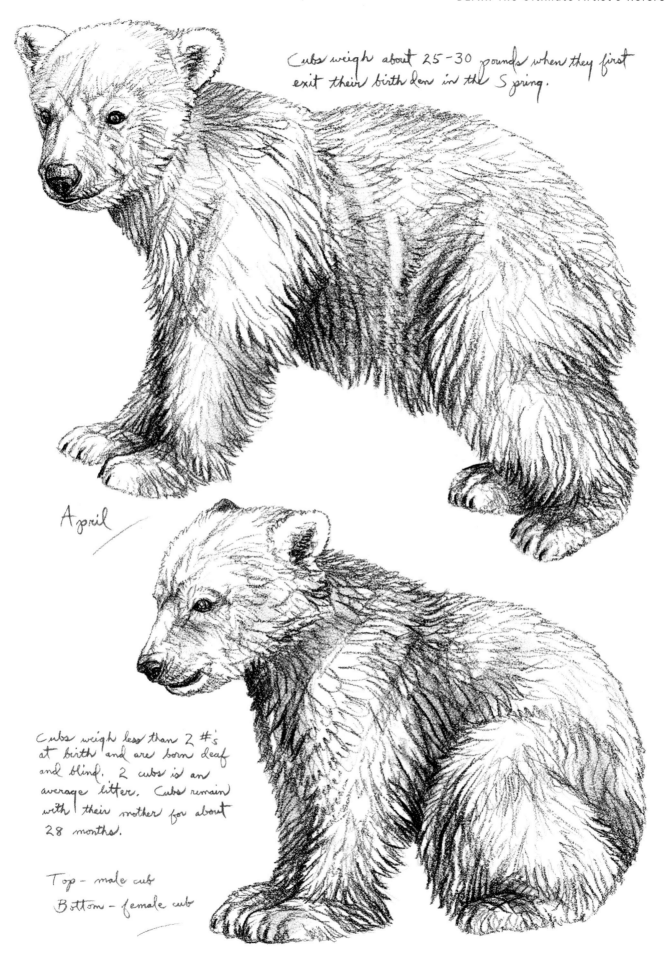

Cubs weigh about 25-30 pounds when they first exit their birth den in the Spring.

April

Cubs weigh less than 2 #'s at birth and are born deaf and blind. 2 cubs is an average litter. Cubs remain with their mother for about 28 months.

Top - male cub
Bottom - female cub

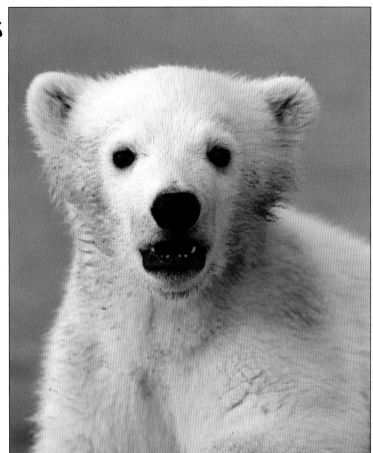

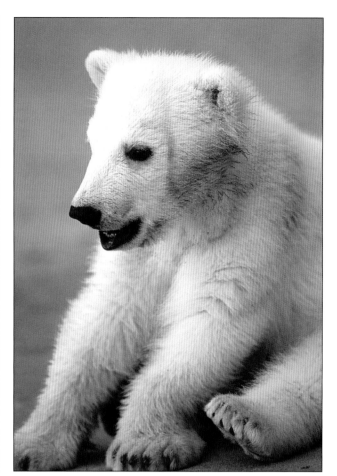

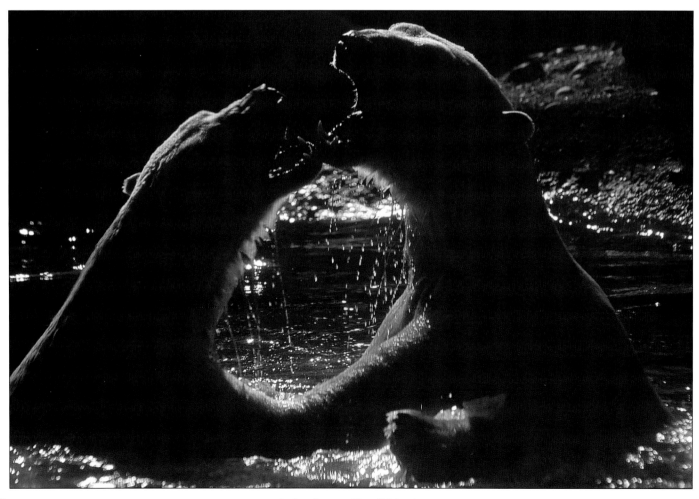

Polar bears (April/May)

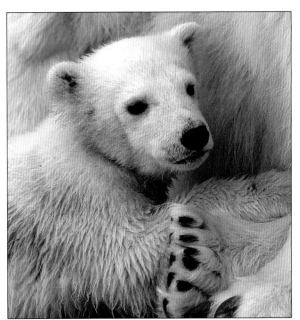

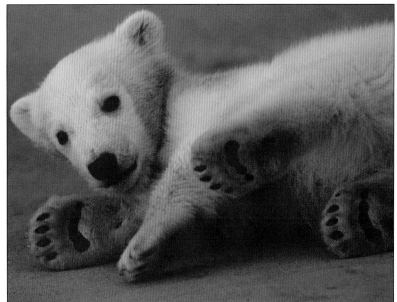

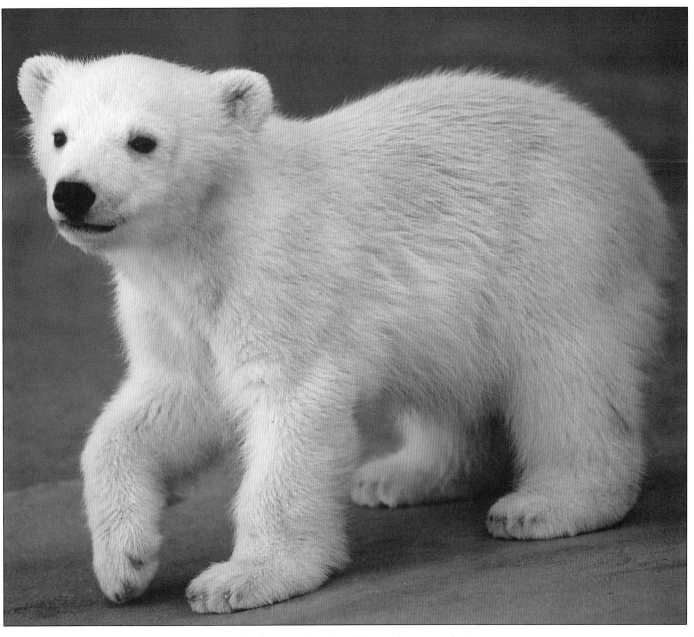

Polar bear cubs (April/Zoo photographs)

Polar Bears

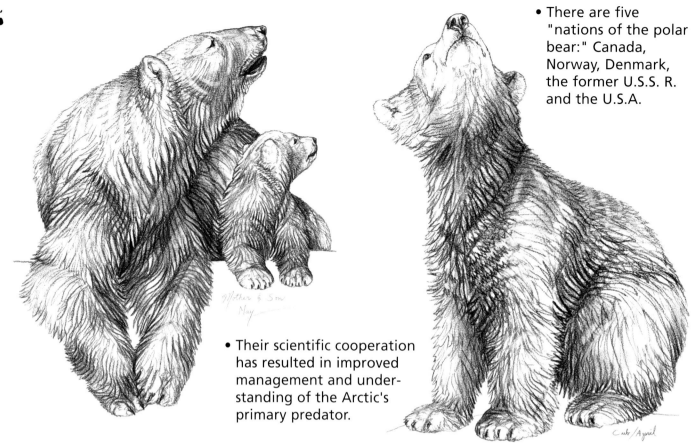

• There are five "nations of the polar bear:" Canada, Norway, Denmark, the former U.S.S.R. and the U.S.A.

• Their scientific cooperation has resulted in improved management and understanding of the Arctic's primary predator.

Mother & Son May

Cub/April

• Strict hunting regulations limit the harvesting of polar bears to northern native people, and usually about a thousand bears are killed annually.

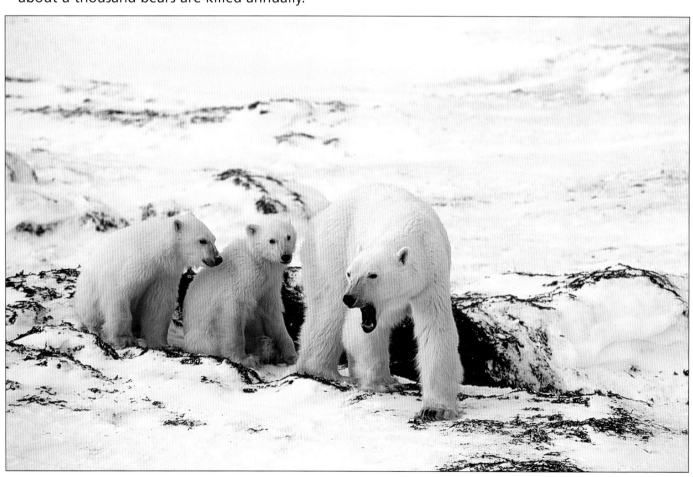

This polar bear female's cubs are about one year old.

• Mating normally takes place around April, but the female bear is able to delay implantation until around September. Then, depending on her health and fat reserves, she implants a certain number of embryos and seeks out a birthing den for the winter. The cubs are born from late November to early January.

• After leaving the warmth of their winter den, the cubs have yet to acquire a warming layer of fat. They are resistant to cold at temperatures as low as 30 degrees below zero.

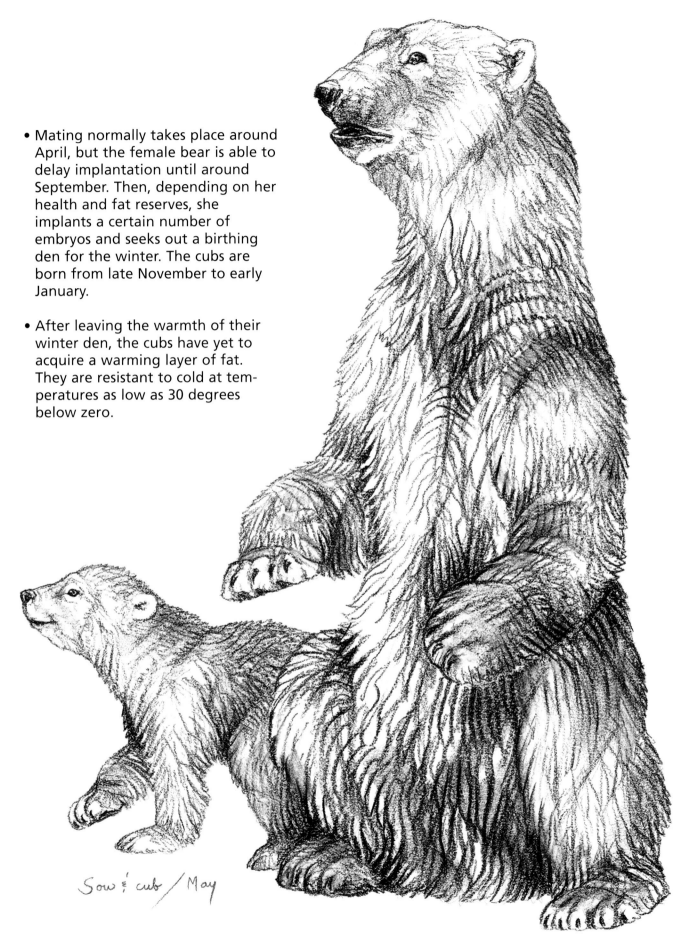

Sow & cub / May

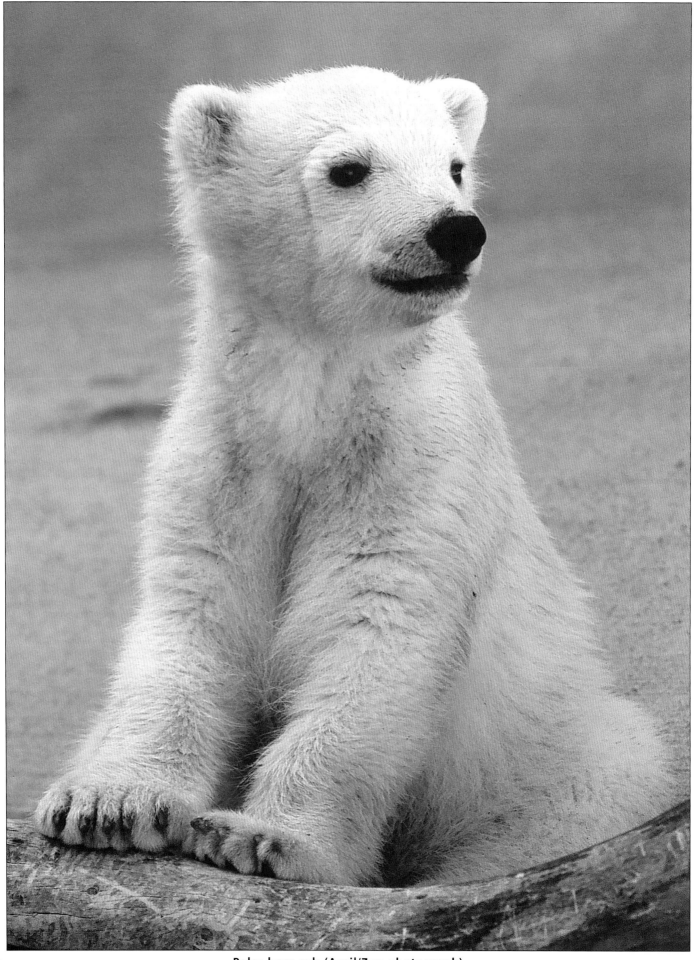

Polar bear cub (April/Zoo photograph)

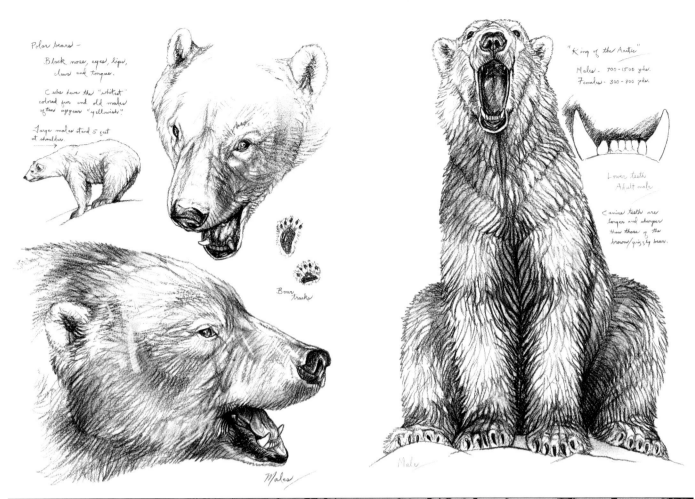

Polar bears –
Black nose, eyes, lips,
claws and tongue.

Cubs have the "whitest"
colored fur and old males
often appear "yellowish".

Large males stand 5 feet
at shoulder.

Bear tracks

"King of the Arctic"

Males - 700-1500 pounds.
Females - 300-800 pounds.

Lower teeth
Adult male

Canine teeth are
longer and sharper
than those of the
brown/grizzly bear.

Males

Male

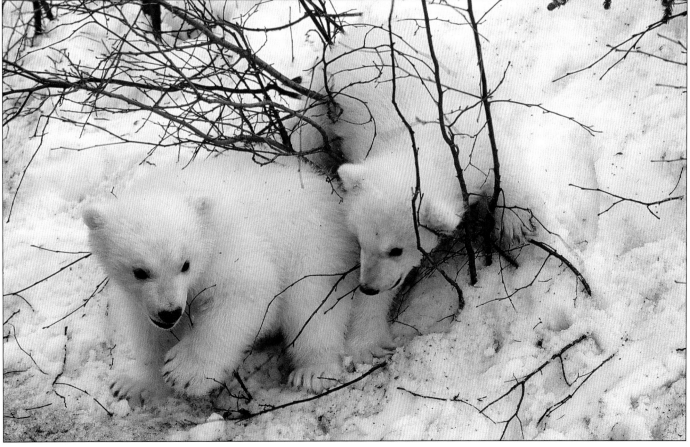

Polar bear cubs (April, about three to four months old)

Polar Bears

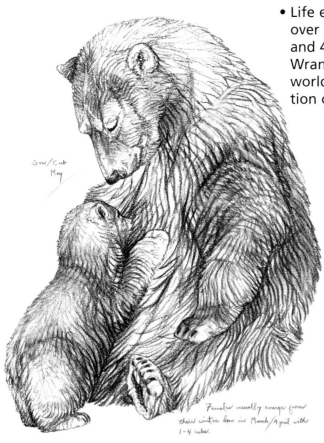

Sow/Cub
May

Females usually emerge from
their winter den in March/April with
1-4 cubs.

- Life expectancy can be over 25 years in the wild and 40 years in captivity. Wrangel Island has the world's largest concentration of birth dens.

- Researchers estimate that about 60 percent of cubs die during their first year due mainly to predation and injury.

Cub/April

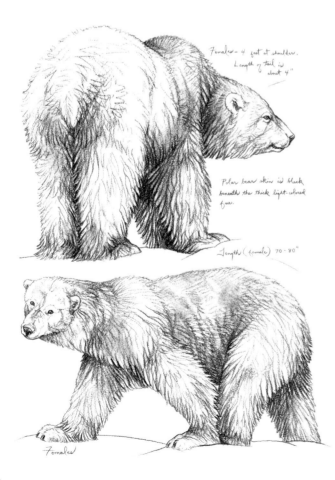

Females - 4 feet at shoulder.
Length of tail is
about 4".

Polar bear skin is black
beneath the thick light-colored
fur.

Length (female) 70 - 80"

Females

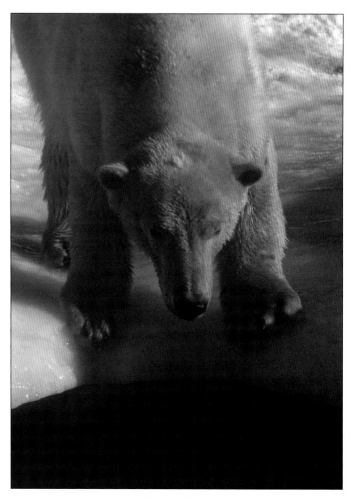

Polar Bear

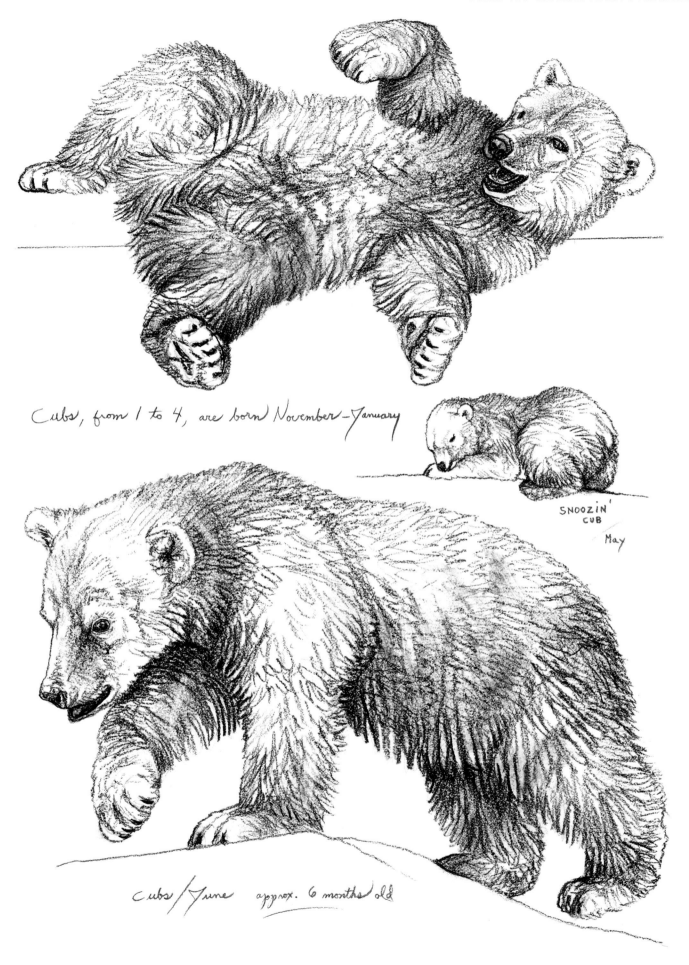

Cubs, from 1 to 4, are born November–January

SNOOZIN'
CUB

May

cubs/June approx. 6 months old

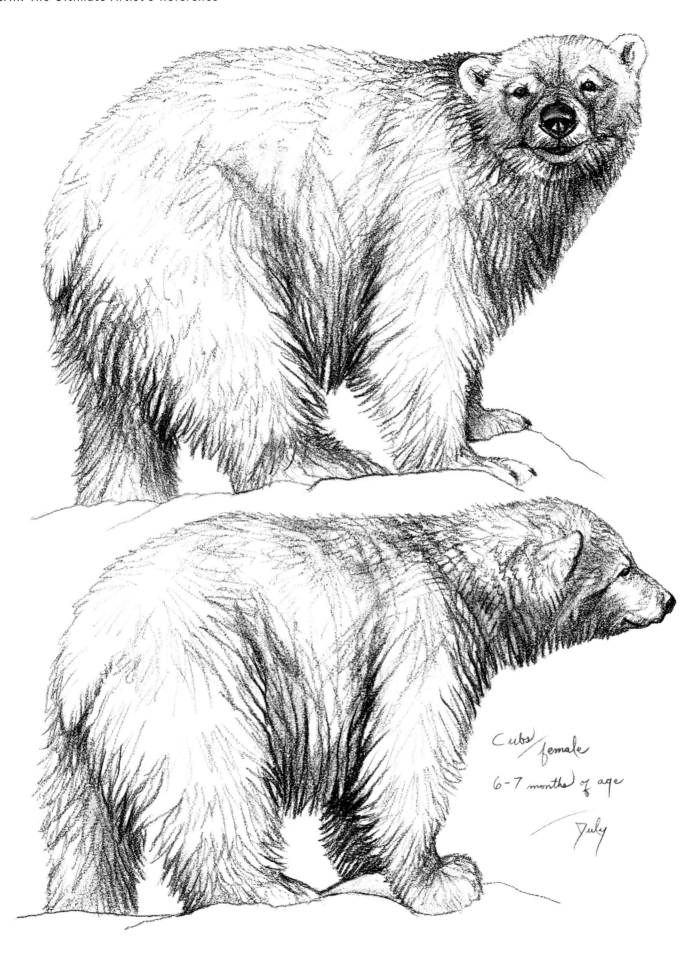

Cubs/female
6-7 months of age

July

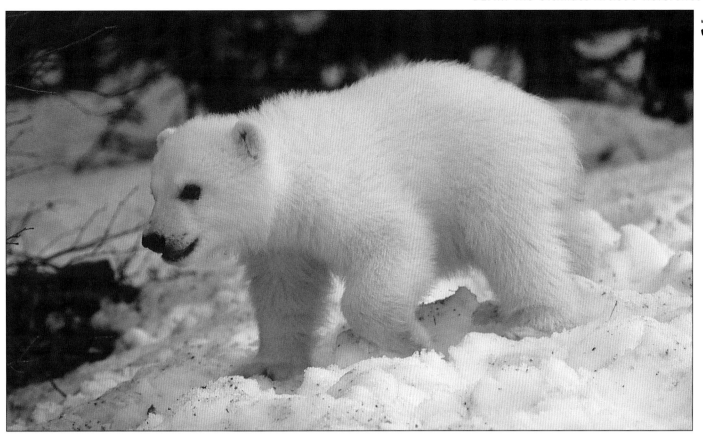

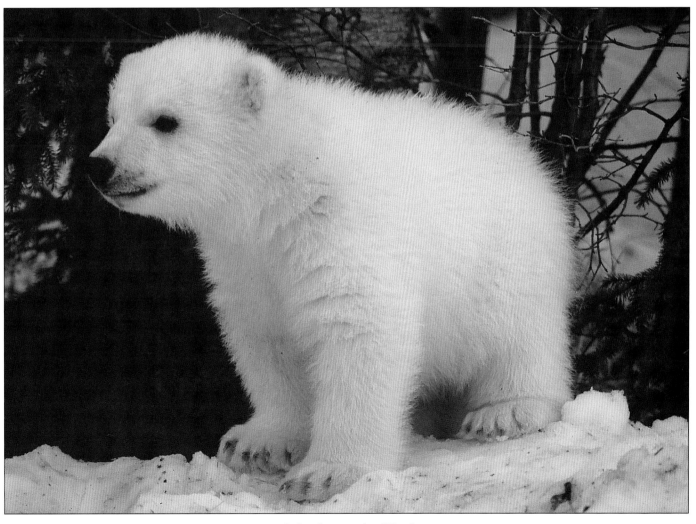

Polar bear cubs (May)

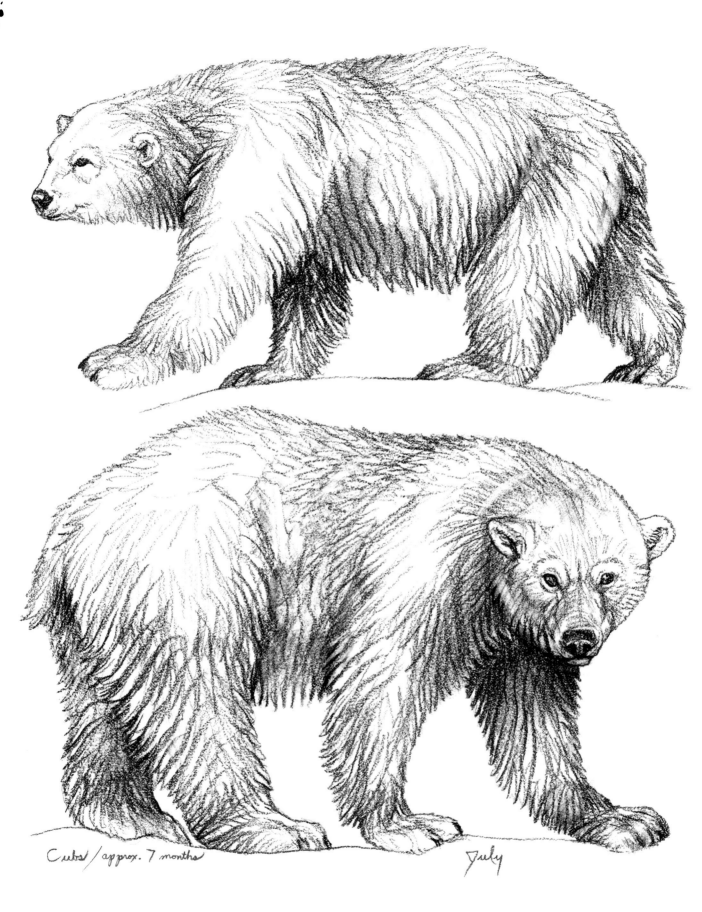

Cubs/approx. 7 months July

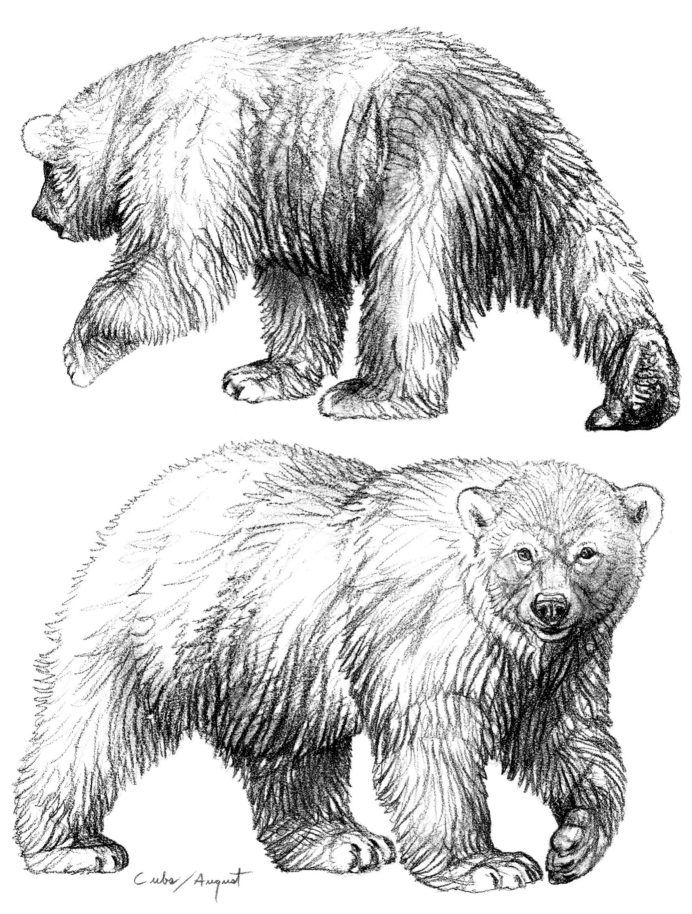

Cubs/August

Polar Bears

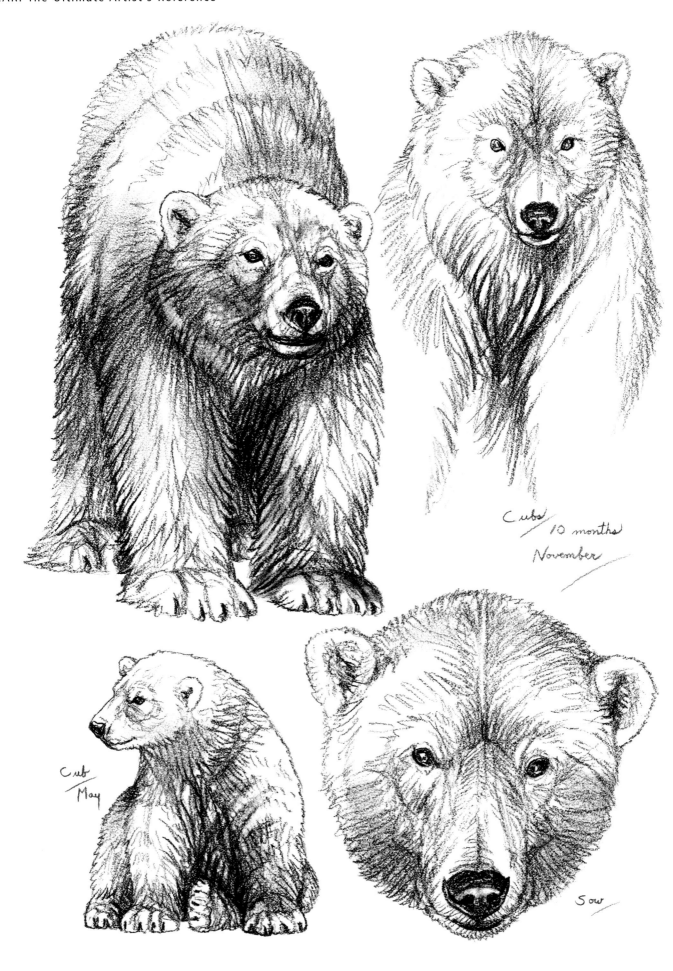

Cubs 10 months
November

Cub May

Sow

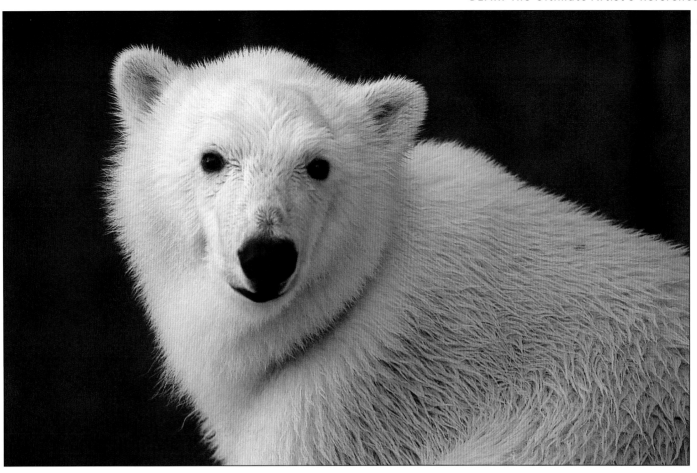

Polar bear, immature (September)

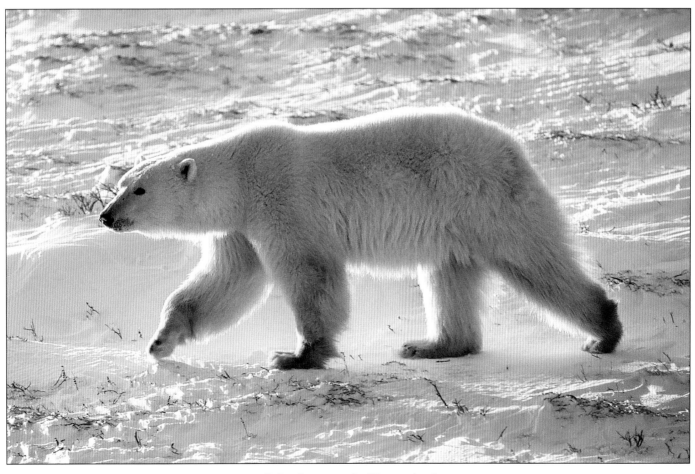

Polar bear, male (November)

Polar Bears

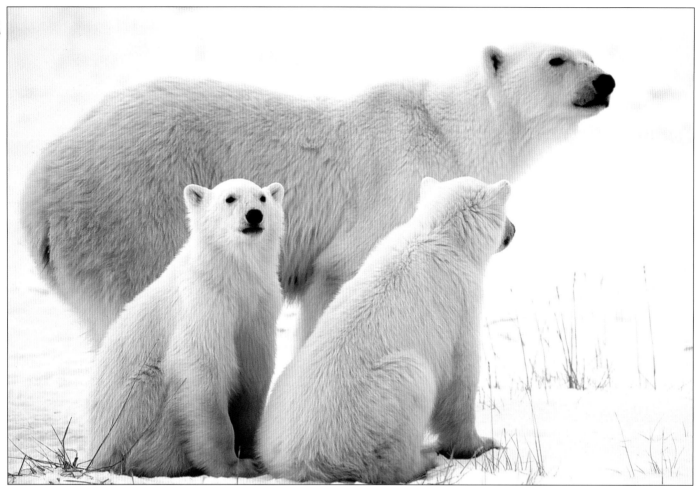

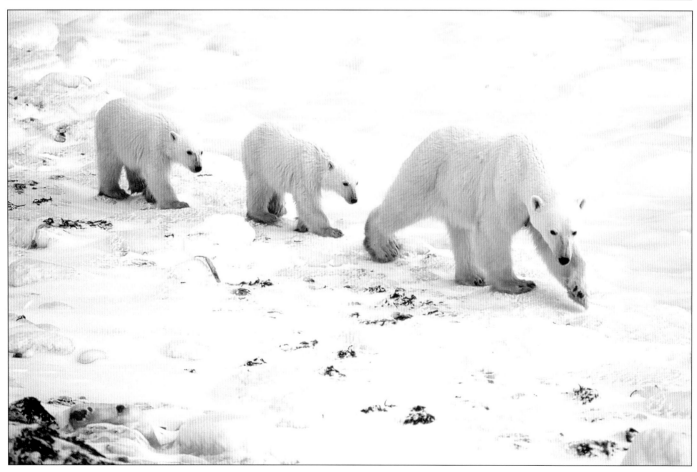

Polar bears, females and cubs (November)

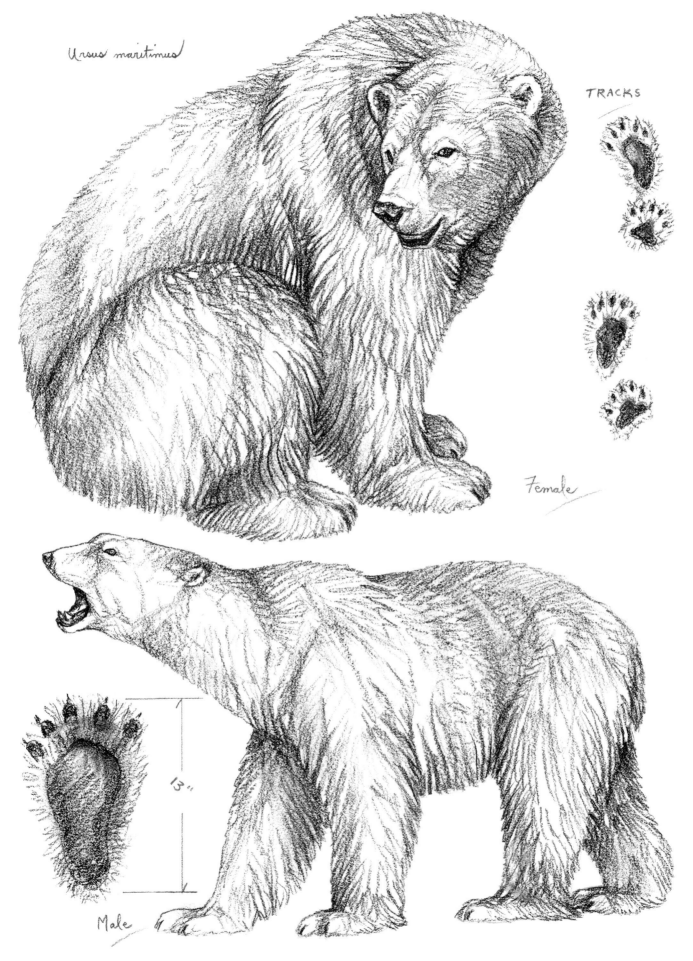

Ursus maritimus

TRACKS

Female

Male

13"

Polar Bears

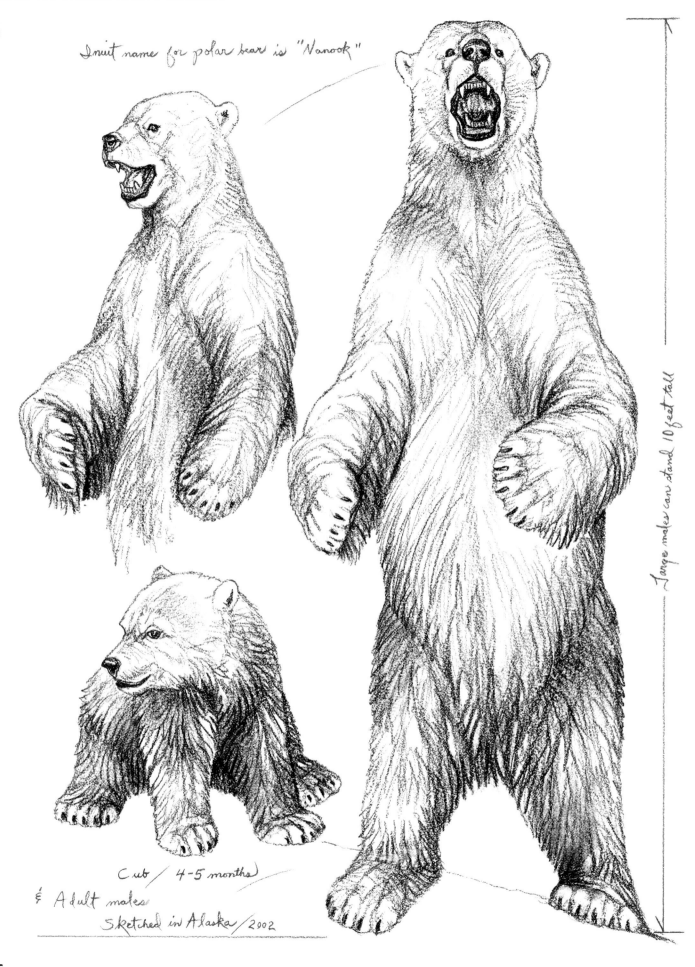

Inuit name for polar bear is "Nanook"

Large males can stand 10 feet tall

Cub / 4-5 months)

& Adult males
Sketched in Alaska / 2002

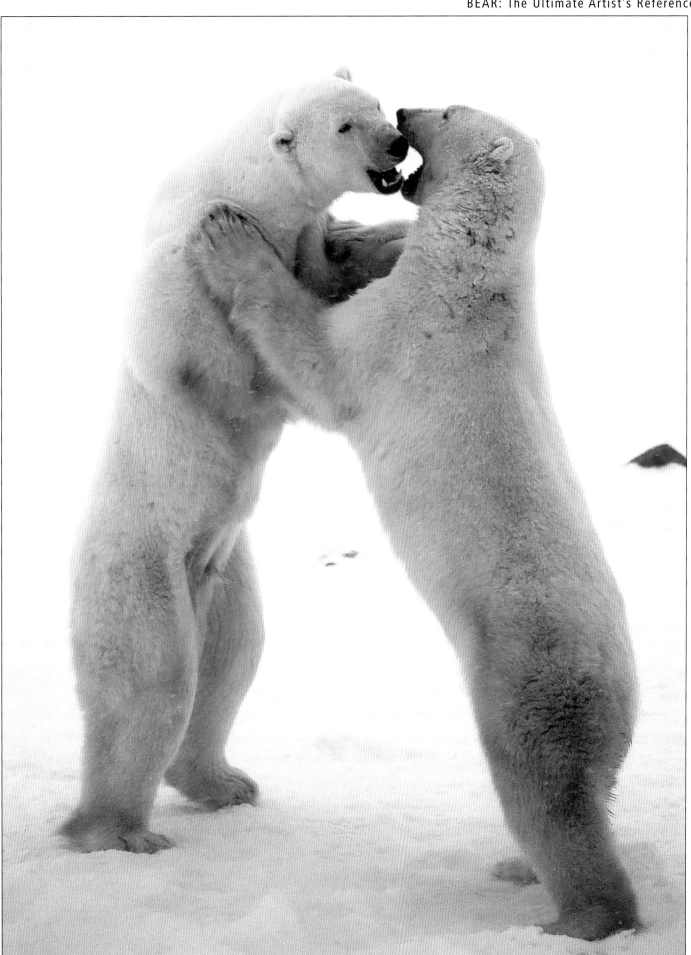

Polar bears, males in "fight-play" (November)

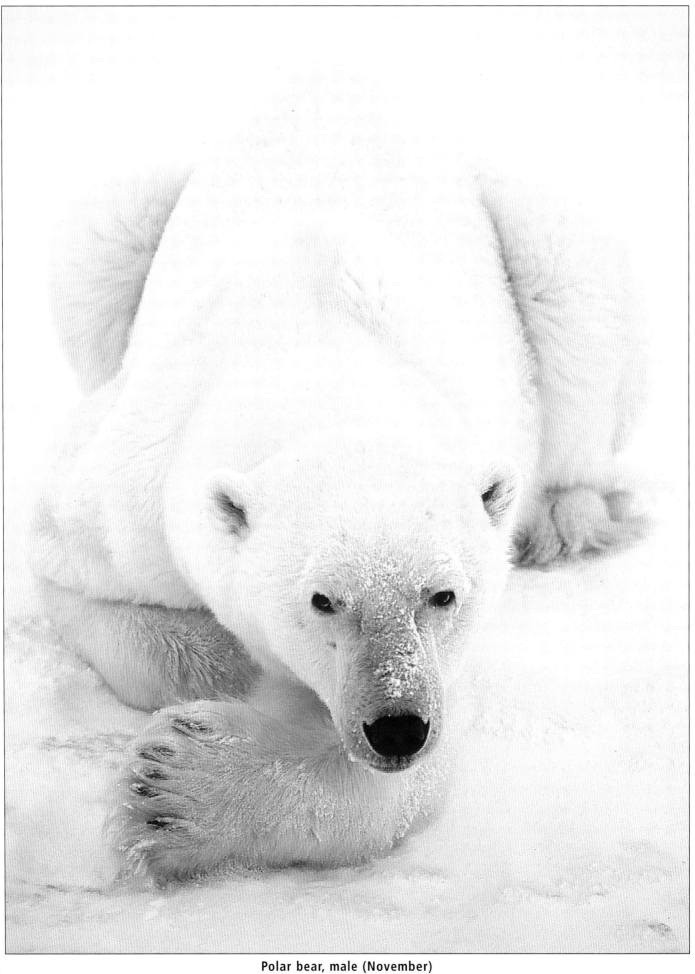

Polar bear, male (November)

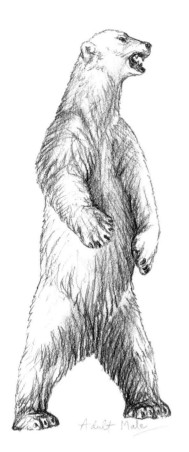

Adult Male

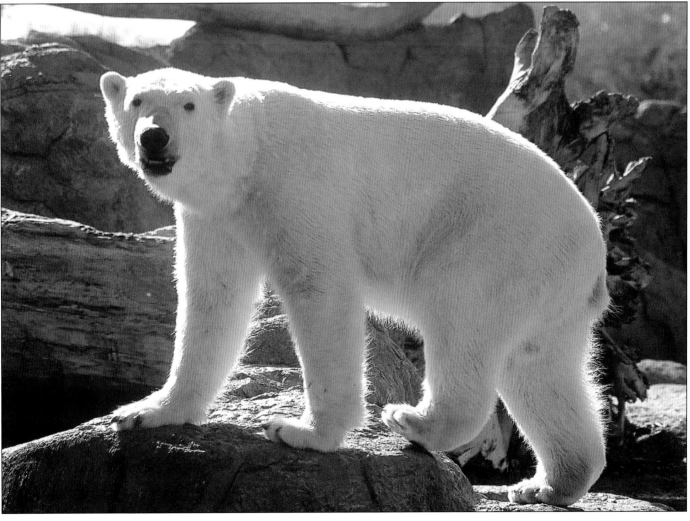

Polar bear, males (March)

Polar Bears

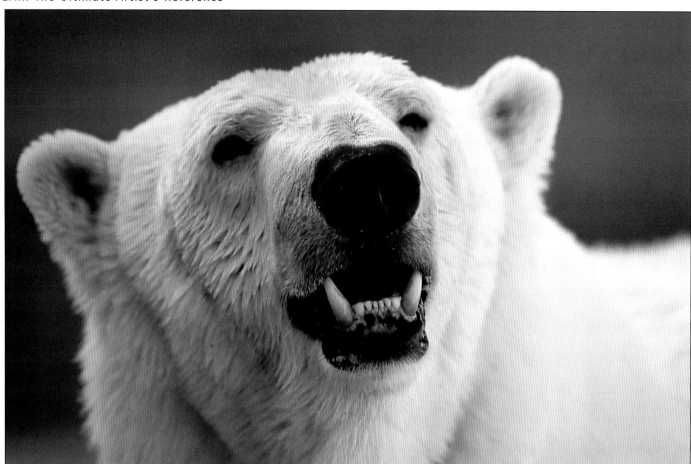

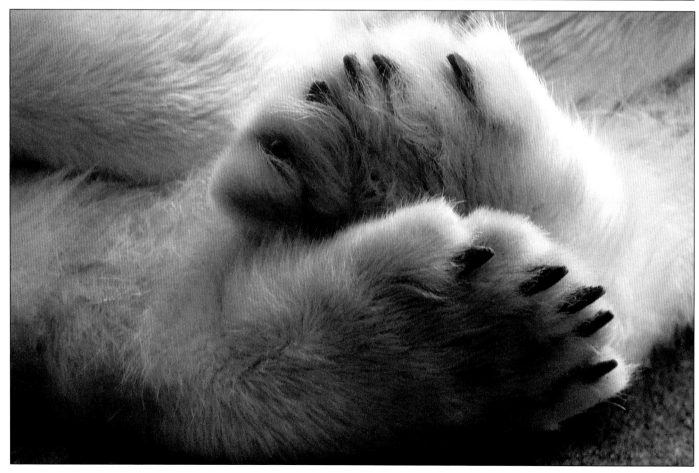

Polar bear, female (May)

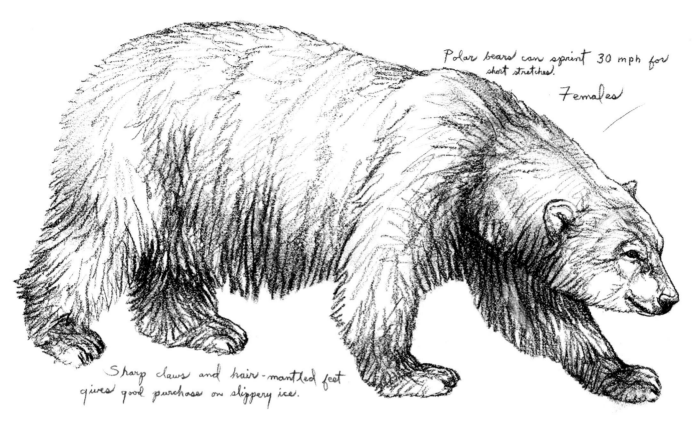

Polar bears can sprint 30 mph for short stretches.

Females

Sharp claws and hair-mantled feet gives good purchase on slippery ice.

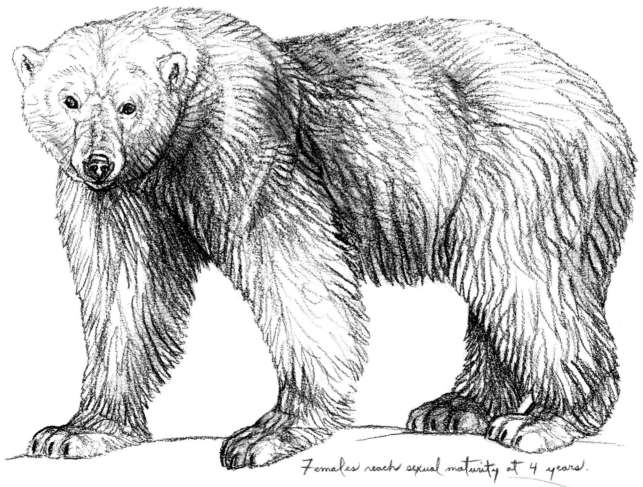

Females reach sexual maturity at 4 years.

Polar Bears

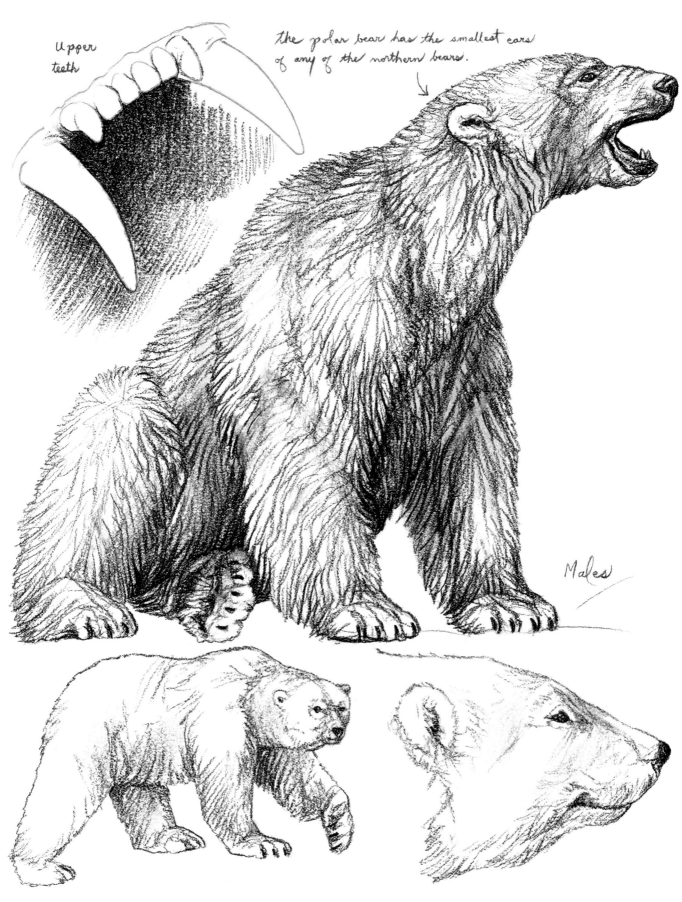

Upper teeth

the polar bear has the smallest ears of any of the northern bears.

Males

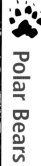

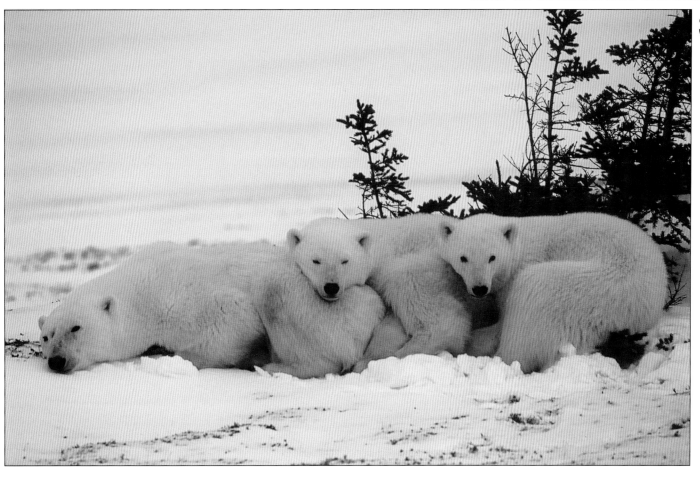

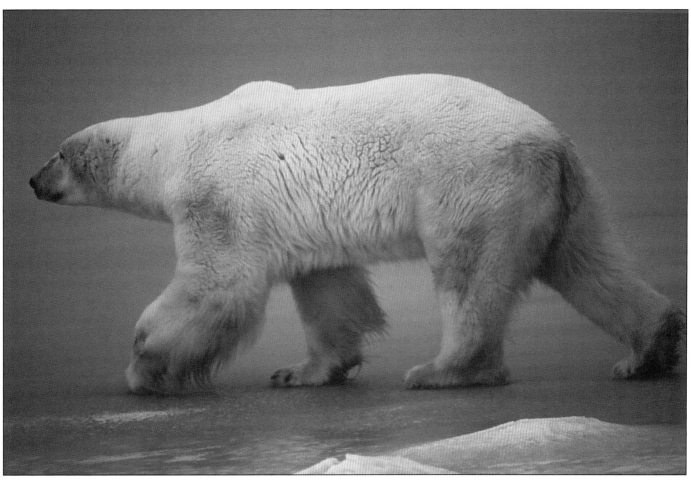

Polar bears (Churchill, Manitoba).

Polar Bears

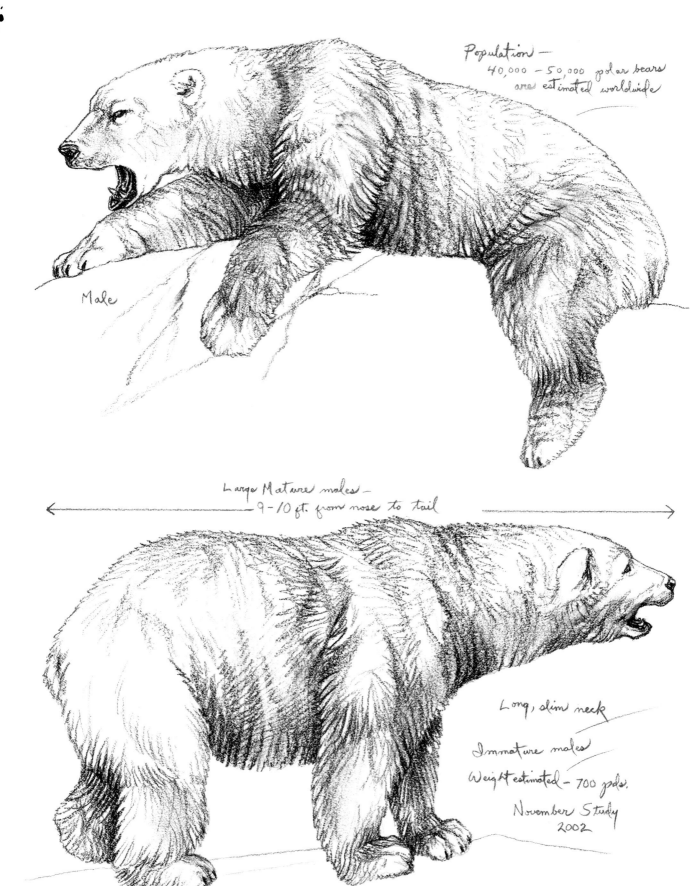

Population —
40,000 – 50,000 polar bears
area estimated worldwide

Male

Large Mature males —
9 – 10 ft. from nose to tail

Long, slim neck

Immature males
Weight estimated – 700 pds.

November Study
2002

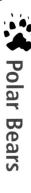

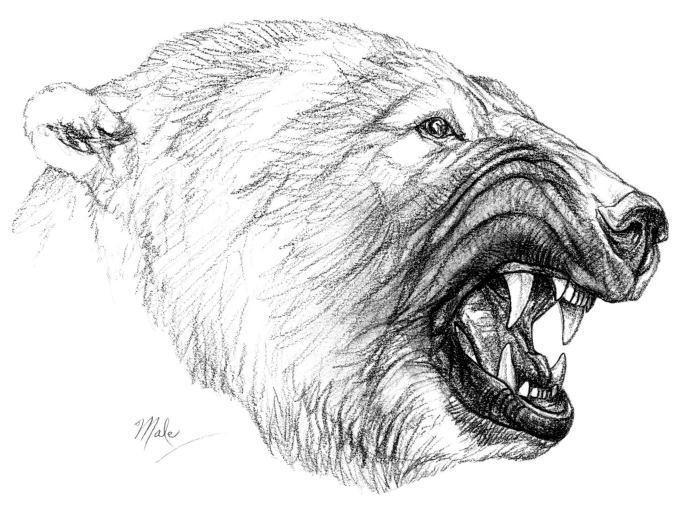

Male

- A polar bear's canines are longer and sharper than those of the brown bear. Also, because the polar bear is strictly a meat eater, its rear molars are smaller than the molars of the predominantly vegetation-eating brown bear.

- Most bears have a sense of smell that is phenomenal. A polar bear, for instance, can detect a hidden baby seal from a mile away and carrion from over ten miles.

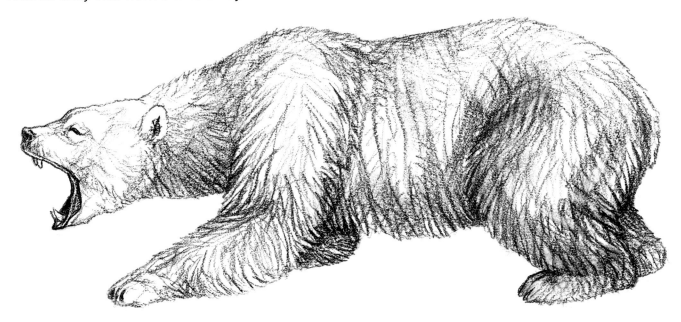

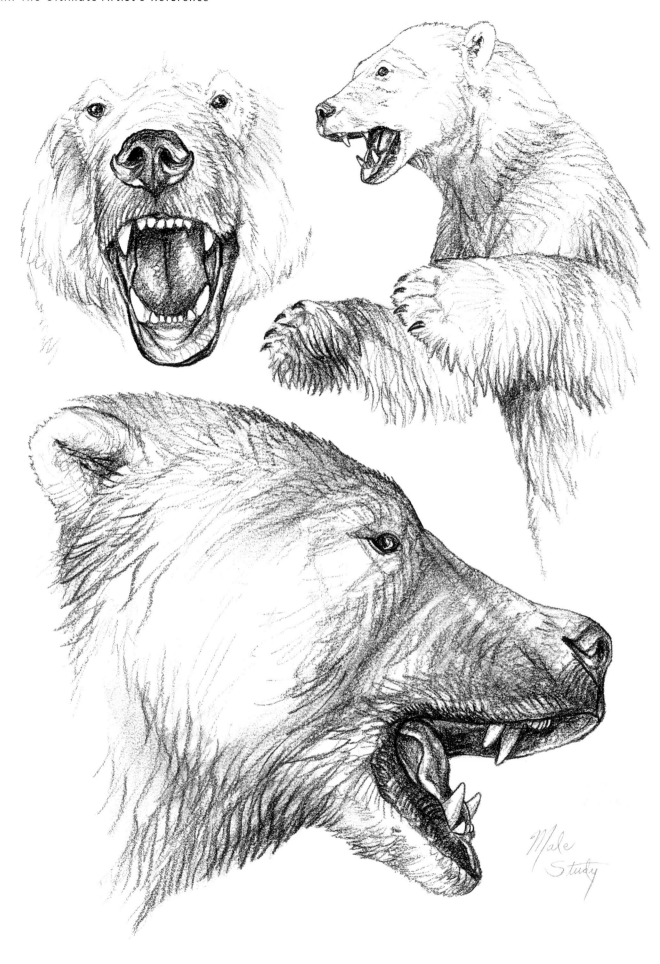

Male Study

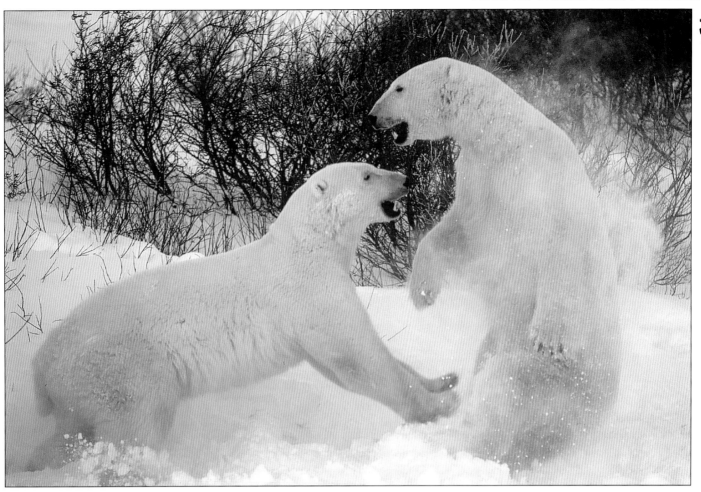

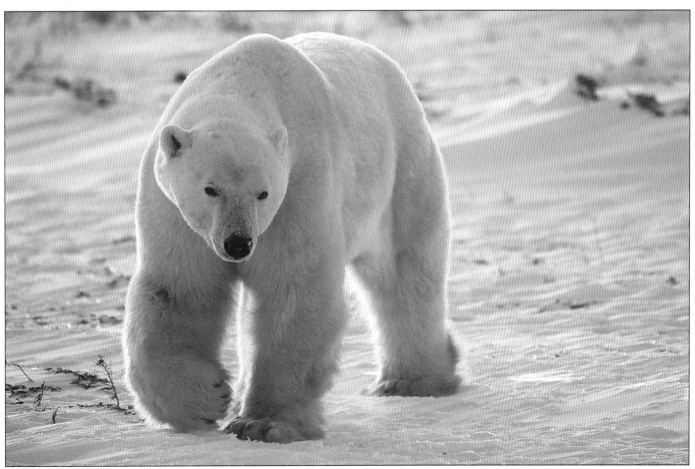

Polar bears (November)

• The polar bear diet consists mainly of seal, walrus and occasional whale and carrion. Walrus and seal are very wary prey, and many stalks must be undertaken before one is successful. One study suggested that only 10 to 20 percent of stalks resulted in a kill.

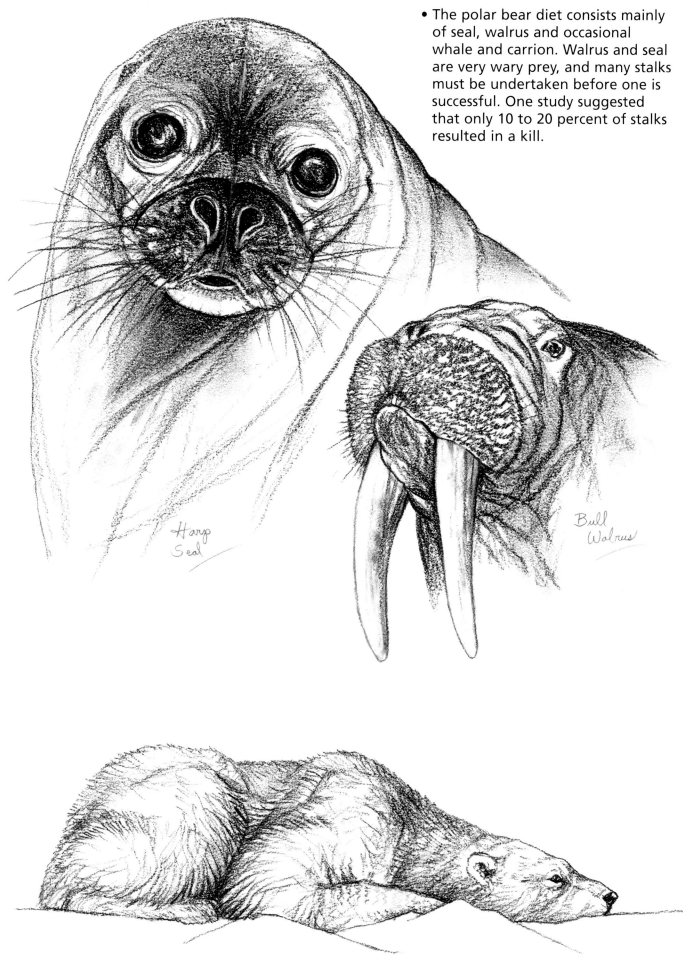

Harp Seal

Bull Walrus

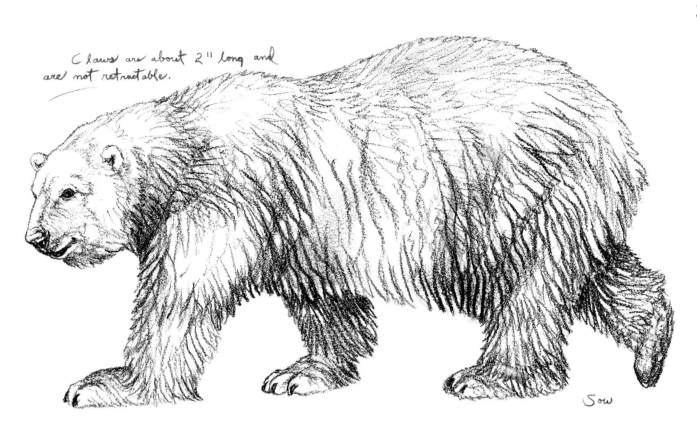

Claws are about 2" long and are not retractable.

Sow

- A hunting polar bear will often creep slowly across the snow and ice, pausing if the seal or walrus prey should look its way. Seals will often position themselves with the wind at their backs, therefore allowing them to smell a predator approaching from behind while seeing anything approaching from the front.

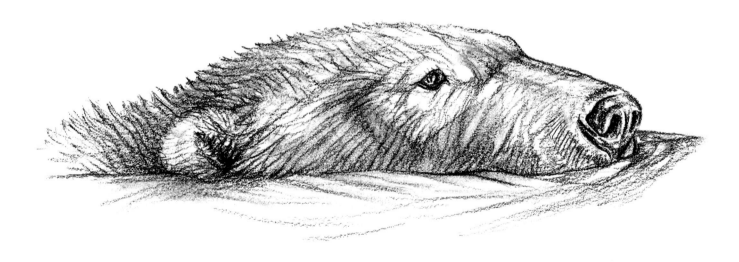

- Classified as a marine mammal, the polar bear is very well-suited to water and is often observed swimming miles from land or ice while moving to new hunting territories. A three-inch layer of fat encases its body against the cold, and its long neck helps keep its head above water. Large, front, paddle-like paws propel the bear through the water.

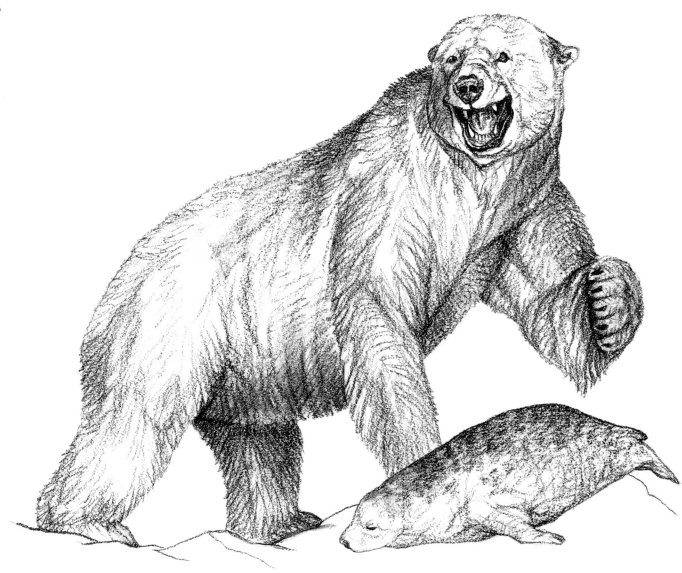

• Ringed seals are favorite prey for polar bears. Polar bears often hunt seal "breathing holes" through which seals enter and exit the sea. Here the bear must remain absolutely silent and still, as any movement or noise would alert the seal. When the seal pops up in the hole to breathe, the bear snags it with its sharp, curved claws and quickly crushes the seal's delicate head with a lethal bite.

• Other times the polar bear will stalk seals that have hauled-out on the sea ice. This slow, patient stalk allows the hunter to sometimes get within range of the resting prey. Then the bear can rush and catch the seal before it can escape to the safety of the water.

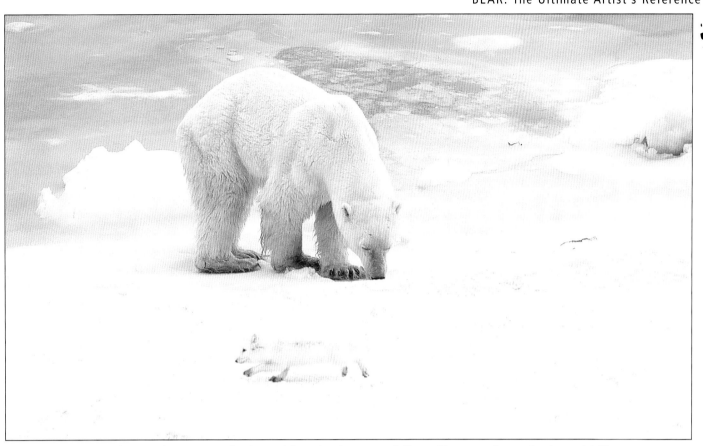

Arctic foxes often roam the ice with polar bears and live off scraps from the bears' kills.
Their coats turn white in winter to match their environment of snow and ice.

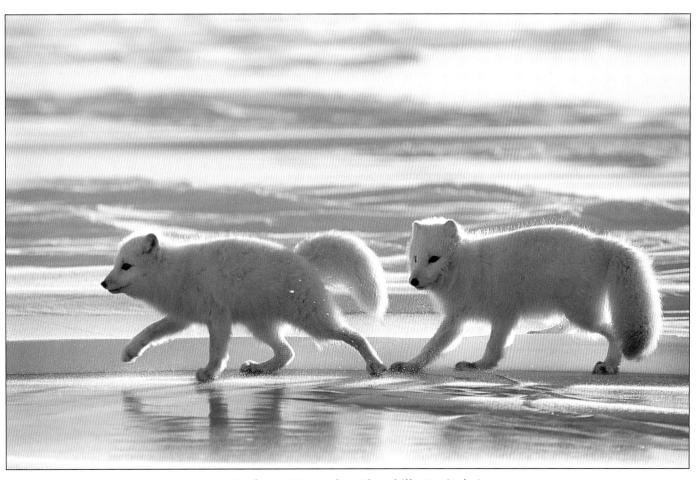

Arctic foxes (November/Churchill, Manitoba).